GOOD OLD DRAWING

G. O. D.

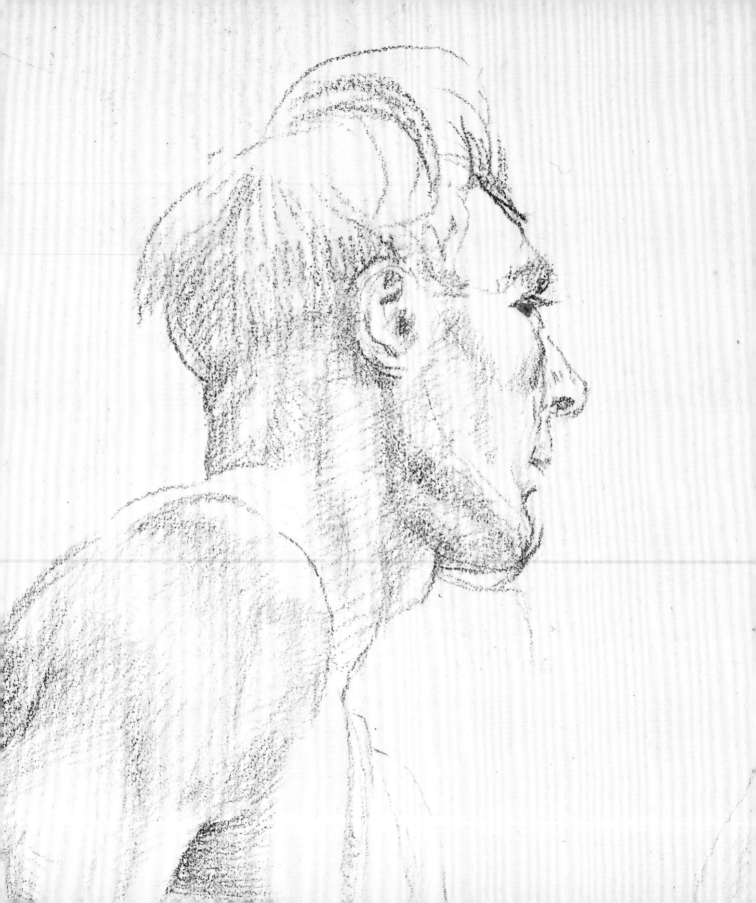

GOOD OLD DRAWING

G. O. D.

A Hundred Illustrators, Artists and Cartoonists who Believe in Drawing

JOHN HOLDER & PHILIP HODGKINSON

HAUS

First published in 2012 by

Haus Publishing Ltd
70 Cadogan Place
London SW1X 9AH
www.hauspublishing.com

Illustrations copyright © the artists

Page and cover design by
Gaye Lockwood and Harry Hall

Printed by Graphicom, Italy

ISBN: 978 1 907822 40 7

Drawing page 4 by Bill Darrell

Nulla dies sine linea
Never a day without a line

Motto of the Cambridge Drawing Society

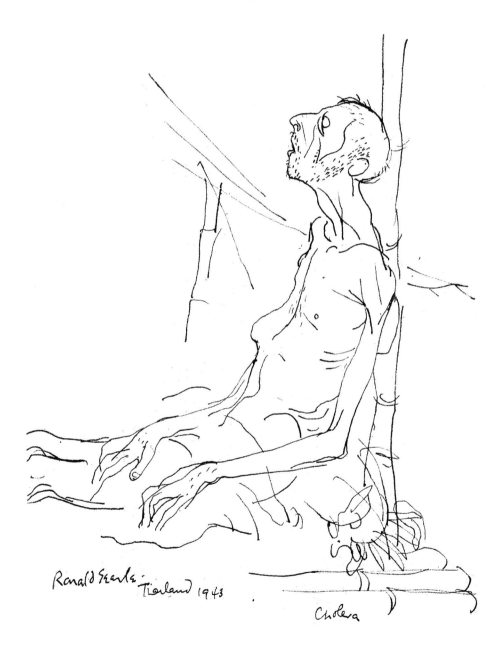

Ronald Searle. Tierland 1943

Cholera

" *Good Old Drawing is a subject very close to my heart and an abiding matter of regret that it appears to have been designed out of the Fine Art curriculum. I have been fortunate to have derived a lifetime's pleasure and profit out of the activity but it has never been easy. Drawing is very challenging and drawings invariably go wrong but once I've drawn something I always feel that I have benefitted from the experience. There are always people and things I wish I had drawn but nobody and nothing that I have ever regretted drawing. I love drawing at party conferences because I can lurk in the shadows with the photographers and the politicians are always there on display. Drawing can capture movement and expression because it is a form of thinking; ideas as well, not to mention jokes as they unfold before my eyes.* "

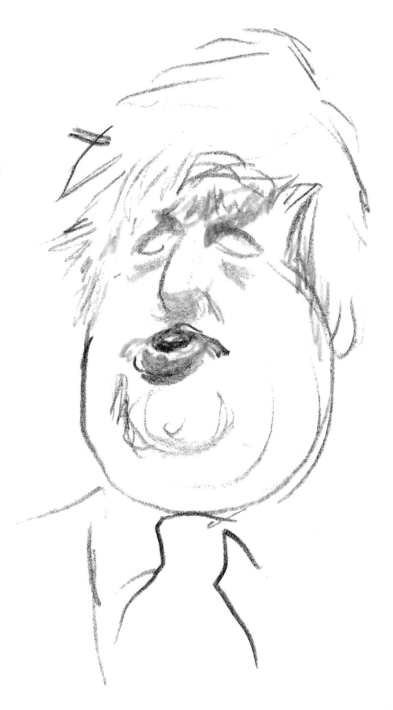

Thinking on Paper

In an age of the virtual, when the chosen means of expression for many artists is film, photograph, text or even sound, the primacy of drawing may seem under threat. However, in many instances, drawing remains as crucial for artists who are at the forefront of innovation as it does for those who maintain a commitment to a more traditional language.

Over the past month alone, in viewing exhibitions in England and on the continent, I have found myself totally absorbed by groups of drawings and prints by artists as diverse as Piet Mondrian, Agnes Martin, Richard Tuttle, Rachel Whiteread, Gerhard Richter, Victor Willing, John Cage, Peter Doig, Michael Craig-Martin, Cy Twombly and Tacita Dean. I have also admired more conventional drawing of the kind seen in the sharp observation and economy of line in David Hockney's *Grimm's Fairytales*, or in the dark emotion of Goya and the passion of Manet. Drawing is endlessly appealing in its immediacy or intimacy and in its discursiveness or precision. These qualities are as present today as at any time in the past.

This book is a celebration of drawing and an expression of its enduring importance to artists of different generations, experience and outlook. Each has developed a personal vocabulary to explore or express a set of ideas. At its best, 'good drawing' is about delivering exactly what needs to be done and no more. Contrary to the beliefs of some writers, there is no single form of good drawing any more than there is a single form of good writing, or good music. The challenge is to develop a means of expression that satisfies the need. I can admire the drawings of both Lucian Freud and Cy Twombly, to name artists in one generation, or Peter Doig and Callum Innes in another. But I can also revel in the vision of a Hogarthian commentator such as Steve Bell. Good drawing takes many forms, but must be fit for purpose and is usually achieved only through constant practice. Like writers, all great draughtsmen continually hone their skills. As the Italian painter and writer Cennino Cennini wrote more than 500 years ago in his treatise *Il libro dell'arte* - The Craftsman's Handbook, "do not fail to draw something every day, for no matter how little it is it will be well worthwhile, and will do you the world of good".

SIR NICHOLAS SEROTA
DIRECTOR, TATE

While still at school my art teacher noted that I was trying to make buildings bend. As a young student I was fascinated by townscape but had little interest in architectural representations. Such 'straight' drawing of a place appeared, to me at least, to lack something vital. Then one day my teacher produced a book called *Majorca Observed*, a collaboration between the writer Robert Graves and artist Paul Hogarth. He opened the book to a drawing of a marketplace and it was an immediate revelation. The drawing depicts a large municipal building that overshadows a collection of stalls, crammed with bartering salesmen and punters; off to the bottom left a road, drawn with just a few vigorous downward strokes of pencil. The building central to the composition has its own aura, the lines of it appear to vibrate slightly as though from the sheer concentration of life around it. The punters themselves are drawn in clouds of features, separating out into lone walkers who are rendered in single unbroken lines, each one entirely distinctive. The drawing not only made a mockery of the idea that a drawing of a building or a place had to have the correct number of windows or doors, it demonstrated that there was an underlying perspective to a place that could be captured if properly observed. Furthermore, looking at the drawing taught me something about the act of looking itself: looking at something changed it, again and again. What Paul Hogarth seemed to have achieved was a drawing that captured the point at which the perspective starts to change: as looking begins.

Several years later, married with four children and manager of a successful property and construction business, I found myself in a London art gallery looking at the very same drawing. I had, in the midst of growing a business and raising a family, let my passion for drawing fall by the wayside and being confronted with the marketplace again was a sort of wake up call. I ended up buying the drawing there and then and with the aid of the gallery wrote to Paul Hogarth to express my gratitude for his work and for his continuing, positive influence on my life. I also stated a desire to take up drawing seriously again, after seeing his work. Concerned, in his reply, that I was on the precipice of a mid-life crisis and that I was going to 'do a Gaugin' and leave my family for the South Seas, it took a few letters back and forth before he saw that my enthusiasm was real. He became something of a mentor whose encouragement and criticism were a crucial boost to my practice. I was lucky enough on certain occasions to go 'on location' with Paul and to witness him working firsthand. Though humbling at times for me, it was a dream come true to see how he could transform a place by looking at it. It was, even more than looking at his drawings, an even greater privilege to be almost inside that ongoing process of looking and line making.

Shortly before his tragic passing in 2002 Paul Hogarth put me in touch with a student of his, John Holder, who became another mentor to me and a dear friend. From our regular trips to P.O.S.E.R.S (The Painting, Observational Sketching and Expressionistic Rendering Society) life-drawing class in Cambridge we had a series of ideas to make connections between the world of business and the world of drawing and art. We travelled across the country to places where my business was at work on a new development to observe and draw the town. The projects were scattered across the country and as such we sometimes found ourselves (though we visited some obviously beautiful towns too) in an industrial looking backwater that seemed to have little to offer the travelling artist, at a first glance. However, as we began to draw, the

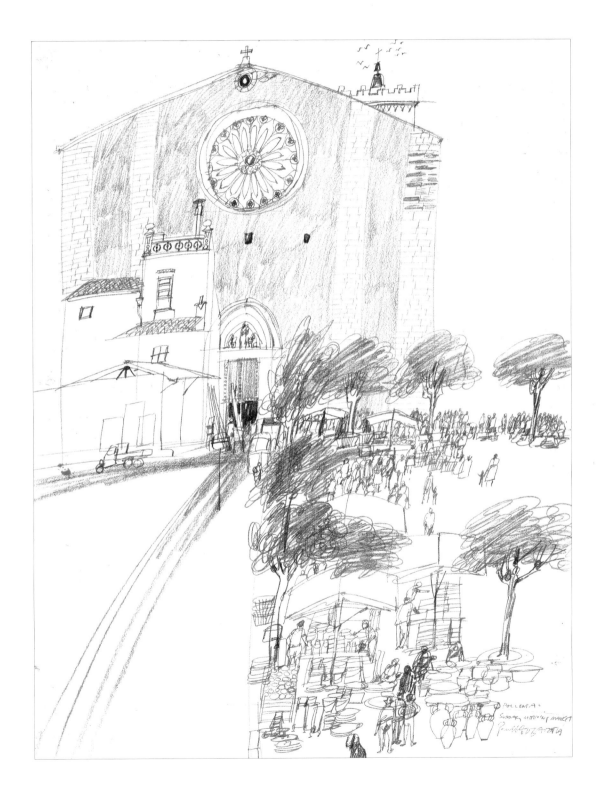

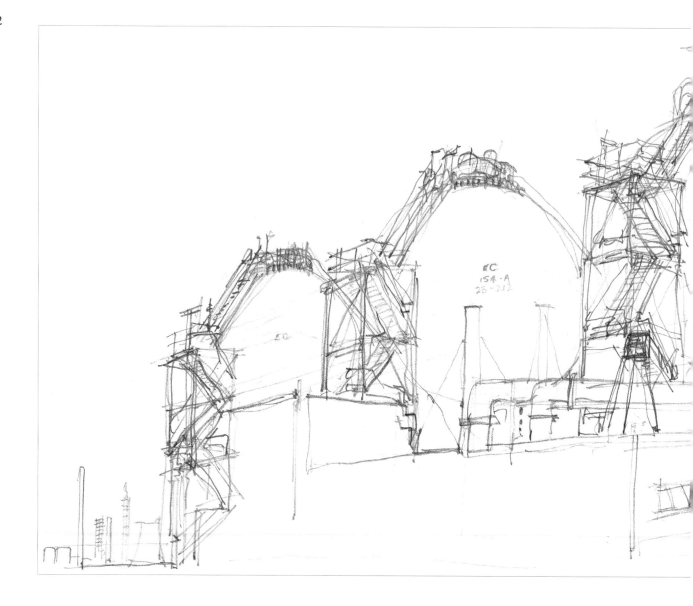

seemingly bland scene in front of us it would invariably prove harder and harder to capture, quietly elusive. There was something about the discipline of drawing that reinvigorated my appreciation of a given place, which in turn gave me a fresh means of approaching our business work there. Through observing a small section closely we gained a greater intimacy with the place we were in the process of literally building on. It was exciting to see how these two worlds talk to each other and still is.

After the success of these trips, John and I together came up with a few more ways that we could forge connections between our two worlds. I established a drawing prize to be judged annually for a single excellent drawing, a small bursary for students at Anglia Ruskin University in Cambridge to go on the annual drawing trip to a European city and lastly, after reading an article about the fight for freedom of artistic expression in Cuba, we created a link with an art college in Havana and send them materials at regular intervals, providing that they get through customs!

Perhaps, however, the best of the ideas John and I have had together is this quirky but important book *Good Old Drawing*. For without drawing none of these bridges would have been established: it is the source and the end in itself. What has united the artists in this book is a desire to share their own discoveries whether it be in a more realistic vein, or an entirely imagined scene. The impulse to share runs riot in these drawings as artists pay tribute to their own influences. I share deeply in this sense of reciprocity and in wanting to give when so richly given to. Without the gift of that single Paul Hogarth drawing of that marketplace I would never have come to make so many connections, to give and receive and to look again.

When I was five my teacher complimented me on my drawing of a daffodil. I had, unlike the rest of the class, noticed a leaf that disappeared behind the stem and re-emerged on the far side. At secondary school the only subject I excelled in was art, whilst my already consuming passion for drawing overflowed into 'extra-curricular' caricatures of the staff, much to the amusement of my fellow classmates. This in turn lead to six of the best from the Headmaster, who I was sent to after my less than flattering portraits. He said I ought to watch myself or I could end up as "a cartoonist or something."

Ignoring this warning I went to art-school in Cambridge in the late fifties and found a place, to my continued joy, where you could literally draw all day long. I thought I had died and gone to heaven. My main influence there was my mentor and friend Paul Hogarth. He showed me that drawing and illustration was a way of life and apart from its gratification it could keep a roof over my head. After graduating I returned as a part-time teacher in a much simpler pre-digital age, in which, to an extent the role of the illustrator/artist was that much more clearly defined. However, though the digital age has accelerated the processes through which work is disseminated, the sheen has started to wear off computer-generated images and practitioners are turning, once again, to the fundamental materials of pencil, pen, brush or any hands-on mark-making tool. Some say that these fundamentals never went away and the book in your hands is an ample testament to this way of thinking. Certainly, on the Cambridge School of Art illustration courses, drawing has always been encouraged, even revered. Sadly however, this is not the case everywhere and this discipline is neglected or even frowned upon. Rather than the positive benefits drawing can have for an artist or illustrator this book is more a reminder of the range of joys that artists are missing out on when they neglect drawing as part of an invaluable creative process.

This book, also, is a kind of happy accident, an unexpected offshoot of my friendship with fellow draughtsman and businessman, Philip Hodgkinson. After meeting Philip and going on several drawing expeditions we decided to follow in the footsteps of his property and development company as it took on major sites, allowing us to visit towns and cities at the far corners of the country. Our search for a worthy subject has taken us under damp underpasses, on muddy building sites, into junk yards, parks, noisy factories, hissing and murmuring robotic warehouses, busy markets and city centres, ports, oil refineries, up windy high-rises and down a deathly silent coal mine. It was all done in the name of our shared passion: Good Old Drawing, which we decided to make slightly more official by turning it into a jokey acronym: G.O.D. From our shared belief in G.O.D. naturally followed the idea to share this passion more widely.

Through a lifetime of pleasure as an illustrator, teacher and drawer, I started collecting 'Believers' in G.O.D. The convenient acronym for Good Old Drawing proved to be an amusing 'hook' and the response has been huge: traditional, contemporary, decorative, observational, imagined, realistic, abstract, humourous, loose, tight, linear, tonal, philosophical.

A cornucopia of work from the disciples of G.O.D.

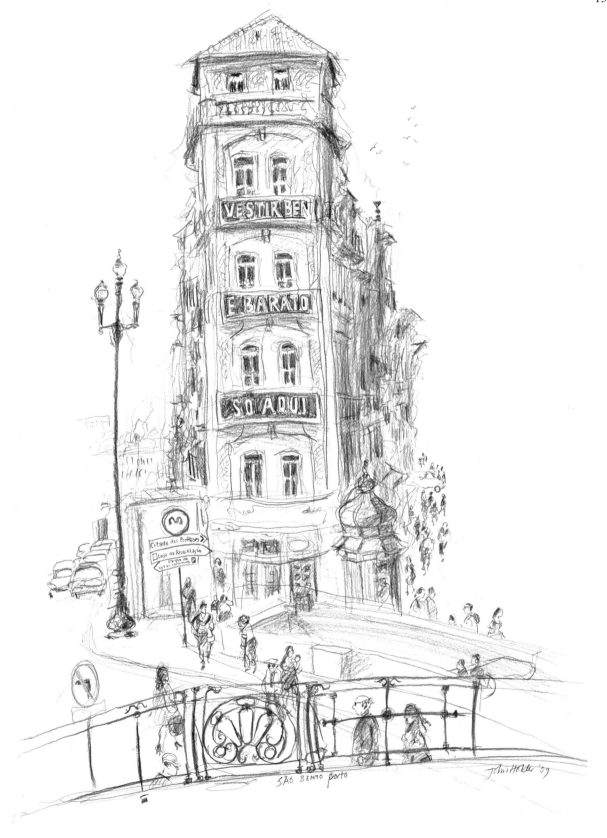

SÃO BENTO Porto

John Holder '09

Drawing isn't what you think it is.

Drawing isn't an 'it' at all….drawing is a 'how'.

A complex ballet of information processing, two-way non-verbal dialogue and extreme fine motor control allows us to process emotion, space, reality and imagination and offer it up to ourselves and others in a form that is instantly and universally understandable… regardless of what language you speak or how old you are.

And just like the spastic seizure that you witness when someone is having an epileptic fit, what you are witnessing happening is not the thing itself….but only the *end* of a long and complex process.

The illustrator Alan Lee said: "To draw a tree, to pay such close attention to every aspect of a tree, is an act of reverence not only toward the tree …but also our human connection to it. This is one of the magical things about drawing—it gives us almost visionary moments of connectedness."

You see, drawing isn't just a nimble synaptic connection between the eye and the hand. It's one of the purist forms of expression. It requires virtually no equipment, yet it can provide transcendence in the hands of a great master or simple, pure communication in the hands of the rest of us.

But unlike a spoken language, the more detail you put into it doesn't necessarily improve the communication. In that regard, drawing is more closely related to music or poetry.

A few simple strokes can express terabytes of complex feeling and physical/spatial relationships.

Drawing from 'life' requires enormous mental discipline, because it demands a level of investigation and observation that is far more intense than merely 'looking'. Our eyes (and optical cortex) are tuned to detect 'edges',

changes in direction or materials, because this is critical to our perception of depth. When we draw from life, we have to prune away the irrelevant 'noise' in the image to a point where the essence is there, but the vast majority of the data are missing. This happens in the brain, not at the end of the pencil. If we didn't, every drawing we did would take several months! It is this essential 'pruning' that lies at the very centre of both drawing from life and drawing from the imagination.

Drawing happens *in the mind*.

You can depict with a few strokes what something is *going* to be, or *could* be, *before it exists*, and it is this that sets it dramatically apart from three-dimensional modelling on the computer, where all the data has to be put in *before* you can see what it is. And, more importantly, you can communicate this 'ghost' to *others*. A concert pianist is several bars ahead when he plays.

You are several steps ahead when you draw.

Drawing teaches you to see, and as such, it is one of the most powerful creative acts you can undertake.

Not everyone can learn to draw brilliantly, any more than anyone can become Paganini, but everyone can learn to *see* through the study of drawing.

John Lennon said: "Everyone can draw until someone tells them they can't."

If you doubt its power, then you are one of the unfortunate people who got told they couldn't draw when they were young…and believed it. If you *can* draw, then you know exactly what I'm talking about.

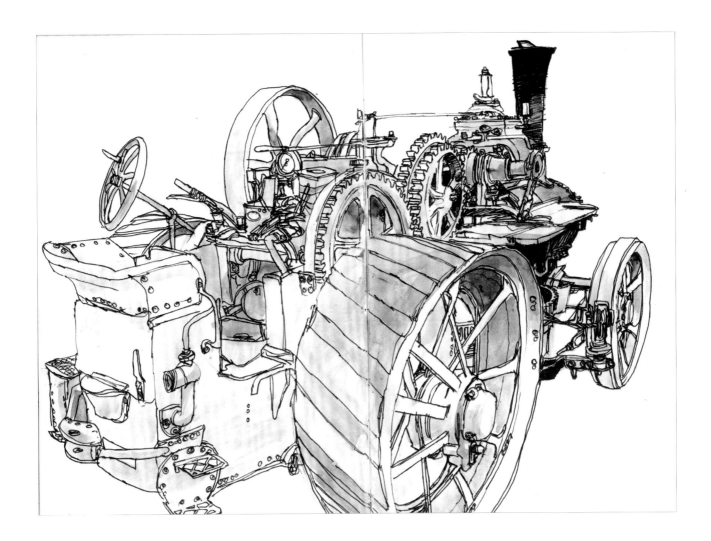

We often think of 'drawing' as a single, simple activity; a stage in a process, a stepping-stone to something more finished. It appears deceptively simple, often using everyday items and lacking much of the paraphernalia of its visual siblings. In many circles the term 'drawing' is used as a derogatory term, a skill based in craft and technique, an unwelcome Cinderella, gate crashing a ball thrown by Painting and Sculpture.

Drawing is however an umbrella term, a multiplicity of activities, each driven by its own motives and reasoning.

From the child drawing in the sand, the architect sketching a concept for a new building on the back of an envelope, the furniture designer experimenting with new ideas in their studio, to the visual journalist out on location, all are trying to make sense of the world around them and to respond to it visually.

Be it the professional or the amateur, the child or the adult, from the joyful and spontaneous to the technical and painstaking, we use the term 'drawing' to cover all of these activities. This is a big ask in anyone's book.

All children draw, but few retain the interest or confidence into adulthood .The question of why some of us still draw and what it offers us as both individuals and culturally, becomes interesting and important.

Drawing encourages us to think visually, to articulate concepts and objects that may not yet exist in a three-dimensional form, and conversely to record three-dimensional objects on a two-dimensional plane, be that a sheet of paper or a computer screen. It also allows us to edit information, to leave out extraneous information and to focus on the important, whereas a camera often captures too much information.

It is ironic that in the sciences of medicine and archaeology, the drawn image is often used in preference to the photographic image. The drawn image is still a method of codifying and simplifying complex information and highlighting important details.

As an educator, I continually question the multiple roles that drawing plays in an increasingly complex digital age, an age where students carry phones with built in cameras and can upload images in seconds. Drawing is not just about recording information in a mechanical, technical way. What is included and what is left out becomes an important decision.

One of the most important facets of the activity of drawing from observation is that it encourages us to understand the world around us by studying it over a period of time; comprehension through visual interrogation.

Drawing is a mental as well as a physical activity and I often use selected quotes to encourage students to consider broader issues surrounding drawing. Going against the old adage, sometimes "a word can be worth a thousand pictures". Many of the quotes on the opposite page have been harvested from books and websites; some are attributed and some anonymous, some pithy and humorous whilst others are philosophical.

Some of them may actually have been said, but all of them ought to have been said…

'I think, and then I draw a line around my think'
A child quoted by *Roger Fry*

'Drawing is taking a line for a walk'
Paul Klee

'Drawing is putting a line round an idea'
Henri Matisse

'To confer the gift of drawing we must create an eye that sees, a hand that obeys,
a soul that feels; and in this task the whole life must co-operate.
In this sense life itself is the only preparation for drawing'
Herbert Read

'I am among the few who continue to draw after childhood is ended, continuing and perfecting
childhood drawing - without the traditional interruption of academic training'
Saul Steinberg

'Drawing is the honesty of art. There is no possibility of cheating. It is either good or bad'
Salvador Dali

'Drawings are the short stories of visual art'
Andrew M. Rauhauser

'It is good to draw anything, it is better to draw everything'
Menzel

'In drawing, nothing is better than the first attempt'
Pablo Picasso

'Drawing...is working through an invisible iron wall that seems to stand
between what one feels and what one can do'
Vincent Van Gogh

'He who pretends to be either printer or engraver without
being a master of drawing is an imposter'
William Blake

Dear John Holder —

Thank God for Good Old Drawing!

I don't think I would have got further in my career than the end of Colin Road, without it.

It has been my *vertebrae* in everything I have ever perpetrated. Good old Drawing freed me to do anything, in any direction, to solve any problem I've encountered over the last sixty years of battling away into pen, pencil & brush.

Obviously, one can master the technicalities, but without a sprinkling of talent in the mixture there is little or no way of advancing into the adventure; Of perhaps advancing into the sheer fascination of the *art*, & pushing it a little further.

For me, it would be difficult to live without it.

Good wishes
& all strength to the campaign.

Yours.

Ronald Searle

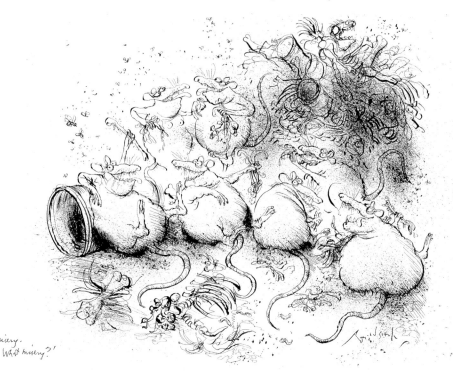

'Misery.
What misery?'

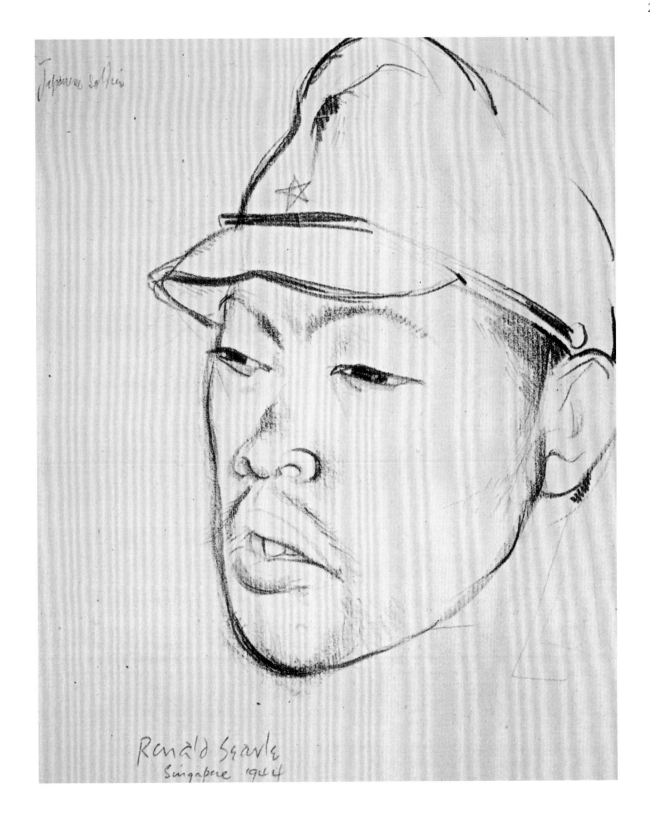

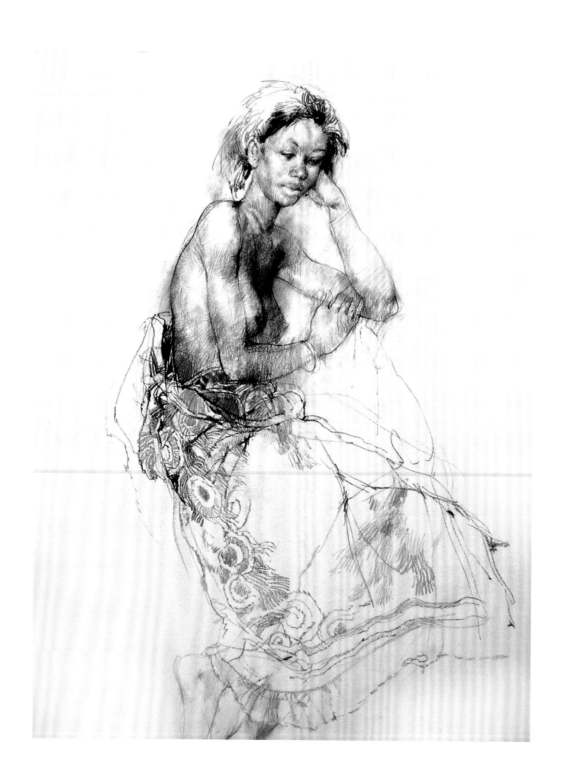

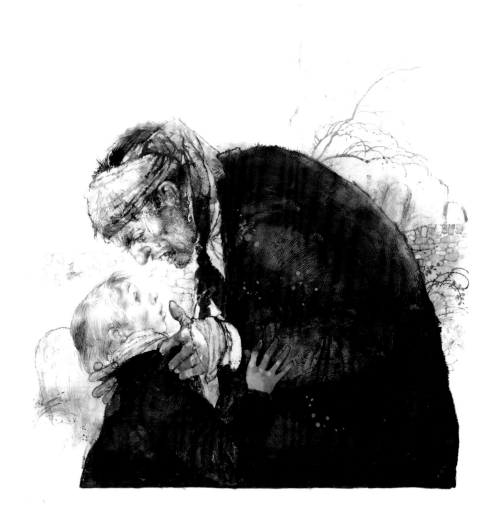

" *I am addicted to G.O.D., having started at about four years old, I have been drawing ever since. I feel guilty if I don't draw every day. It's mostly illustration work, currently the novels of Cervantes. On a very different scale, I draw from life every week, usually about A1 size, always figurative, life drawings or costume models. This helps to top up visual memory for illustration, and keeps me in training! I never use a camera: 'camera copies' are dead losses. Not many places teach drawing these days, most art schools don't bother. I was lucky, I was given thorough grounding in college – I am an oldie! Anyway, stuff the sharks, and lets do some Good Old Drawing!* "

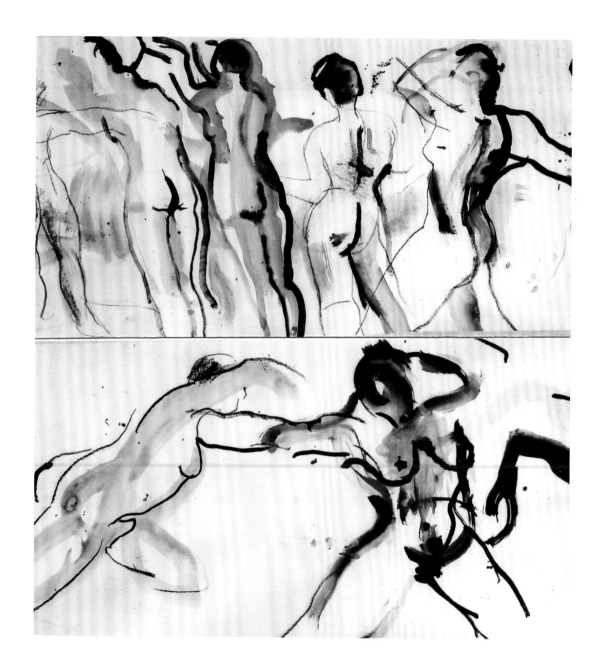

" Good Old Drawing keeps us going! I live to draw and draw to live. "

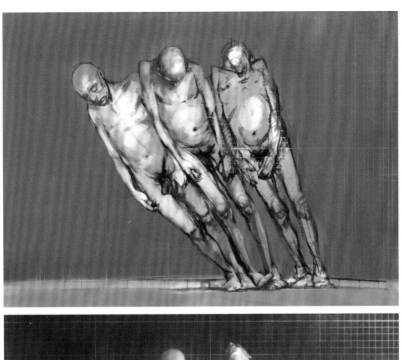

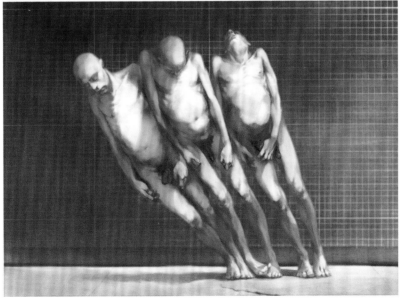

" *The computer has complicated things, more so than photography, or so it seems to me. Its power and flexibility are seductive, its potential apparently limitless and its utility undeniable. But it corrects our weaknesses, and if, as I believe, our failings are what makes us interesting, then ironically, in an age dominated by digital product, drawing seems to be more important than ever! This at least is why I draw, it keeps me honest, reminds me that there is more to the creation of an image than simulation or choice.* "

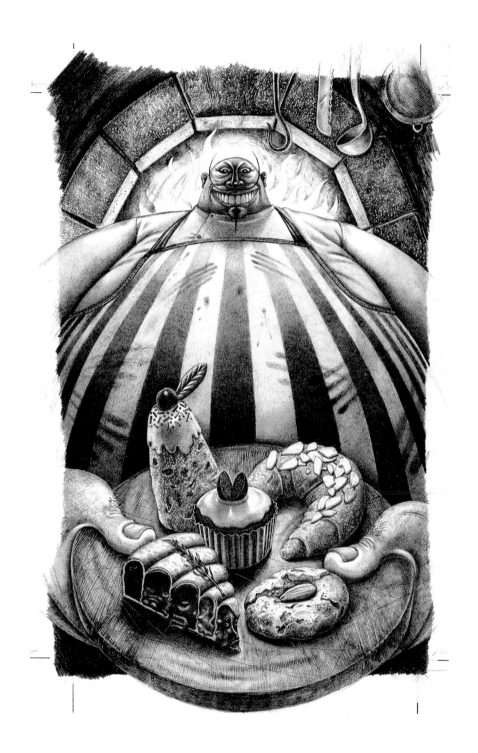

" The pencil is G.O.D. "

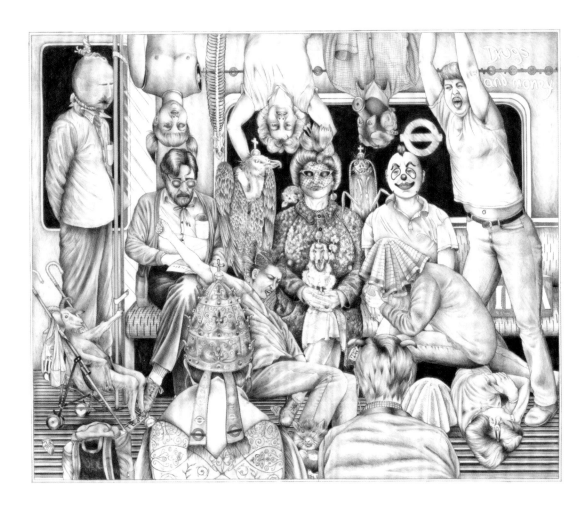

" *I cannot claim to have any high flown ideas about drawing. I went to art school for all the wrong reasons,*
such as, they all looked like they took more drugs than other students. So I am trained to do something that
I have no natural talent for and have lasted because I can't think what else I could fill the day doing apart
from drawing. I usually get bored in the middle of the drawing and wish I had trainees that could fill in the
tedious bits. I am always disappointed with the result so start the next picture in the hope that it will be better.
Always the optimist. "

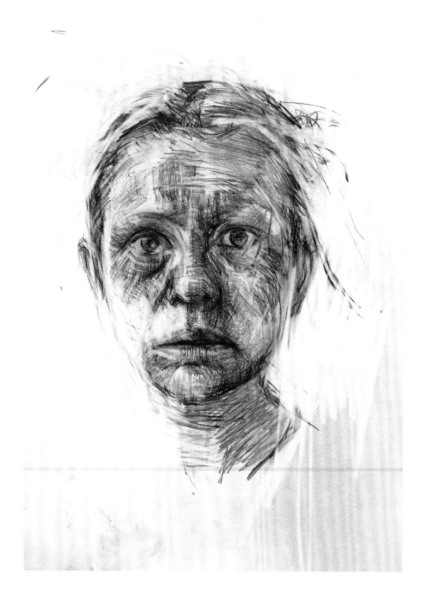

" *For me drawing is fundamental to my sculpture, it seems to lighten me somehow. If I do not draw my work becomes stylized, stiff and awkward; the energy seems to drain from it. Its not something I notice happening but somehow it becomes harder to work, it slows and is difficult to get right. Then I start drawing again and it is as if someone has greased the cogs… the machine starts whirring and spinning again at full pace, anything is possible.* "

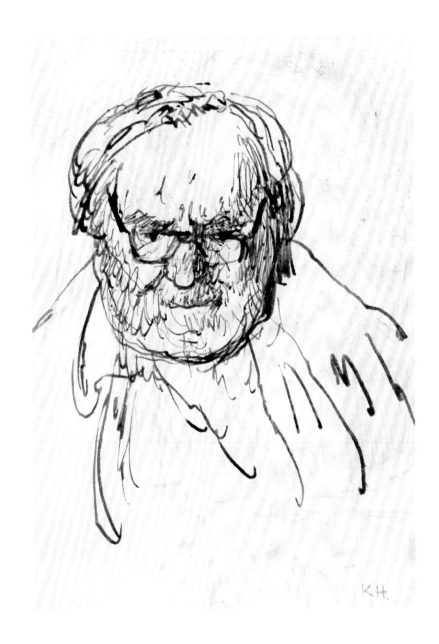

" *Like Sickert I believe "Any fool can paint but drawing is the thing and drawing is the test.
If you are a good draughtsman you are 'ipso facto' a good painter". Drawing is a way of
seeing, a way of revealing the world. As Ben Shahn said "When I draw a pair of trousers I
want people to know if they are a twenty dollar or a fifty dollar pair of trousers."* "

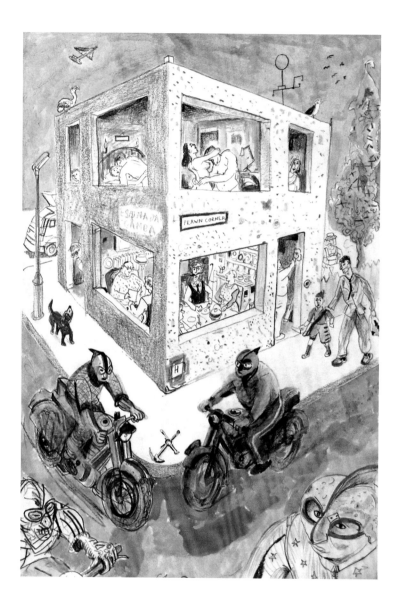

" *The Disobedient Ones! We all draw at some point in our young lives. This primal activity is frequently knocked out of us by 'education'. A world dominated by rational and literal forces finds little time for the imaginative and personal. For those of us who contribute to draw throughout our lives (the Disobedient Ones) there is a blessing and a curse. The wonderful thing is that we remain inside our inheritance, forgetting is almost impossible. Drawing fixes the past and the present in our minds. We can continue to celebrate our childish joys as well as play with our subsequent adventures. On the other hand we have no place to hide, and the truth about our obsessions and stupidities continue with us. The evidence is to hand and fills the plan chests, sketchbooks, museums and patron walls. Long live drawing and the Disobedient Ones!* "

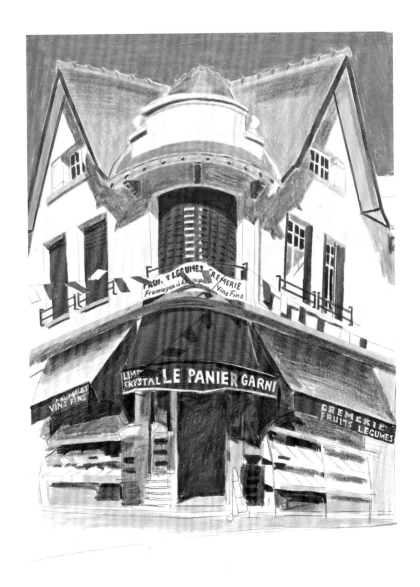

" *His knowledge of architecture and architects was unparalled, it was an education just to visit a cathedral with him. He worked very hard and very professionally. He was serious but not solemn. Drawing was the centre piece of his art and he drew from life with an enviable facility.* "

IAN BECK

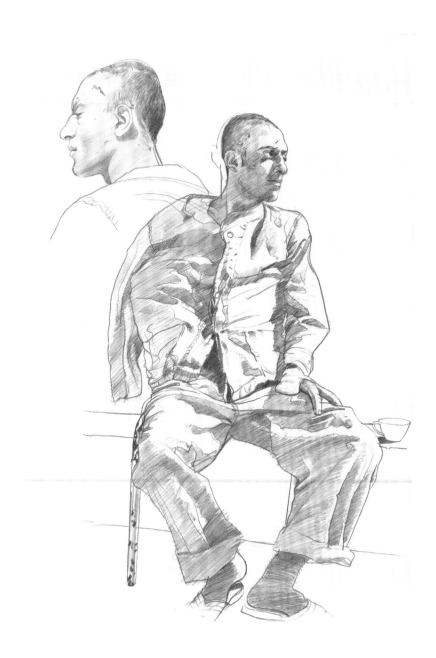

" *When Julian was a boy and discontent was all around he would go up to his room where he would draw....and draw...and draw...G.O.D. It gave him peace and eventually came to give him a career too.* "

<div align="right">VICTORIA ALLEN</div>

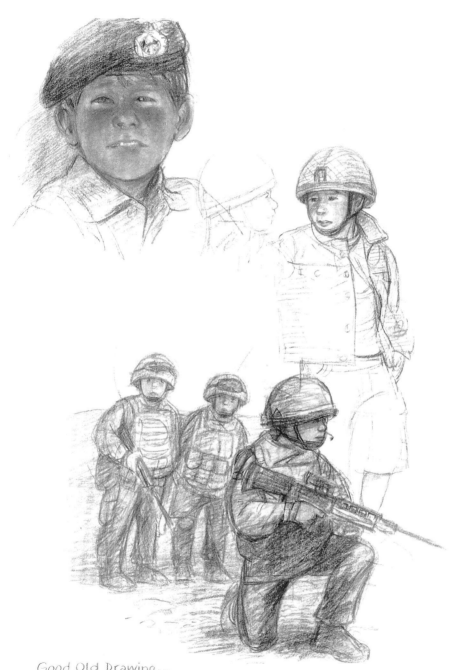

Good Old Drawing...
I think, therefore I draw

Posy Simmonds

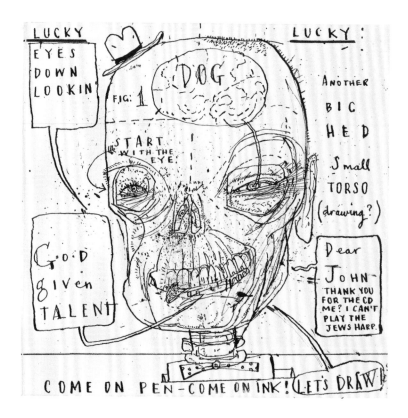

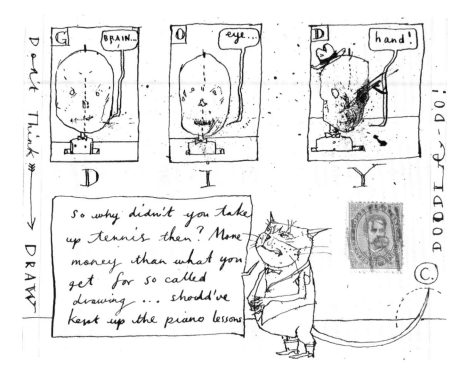

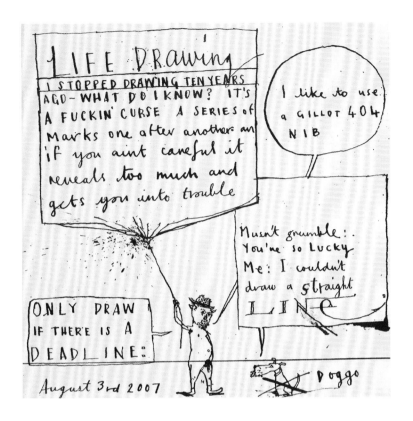

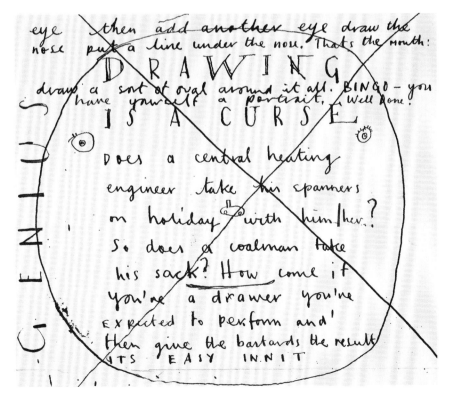

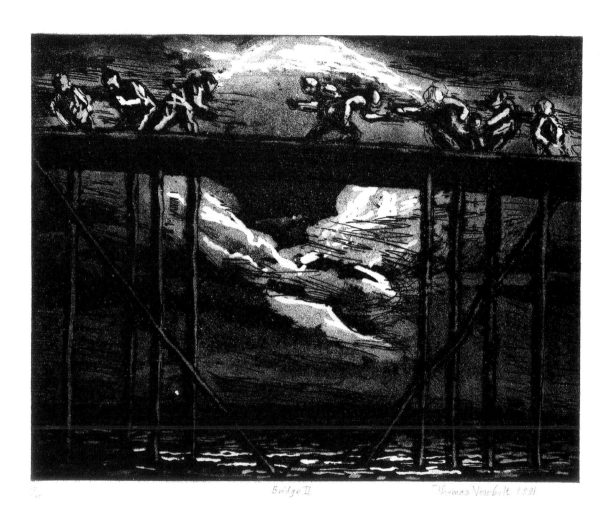

Bridge II Thomas Newbolt 1991

" A line has two sides remember. "

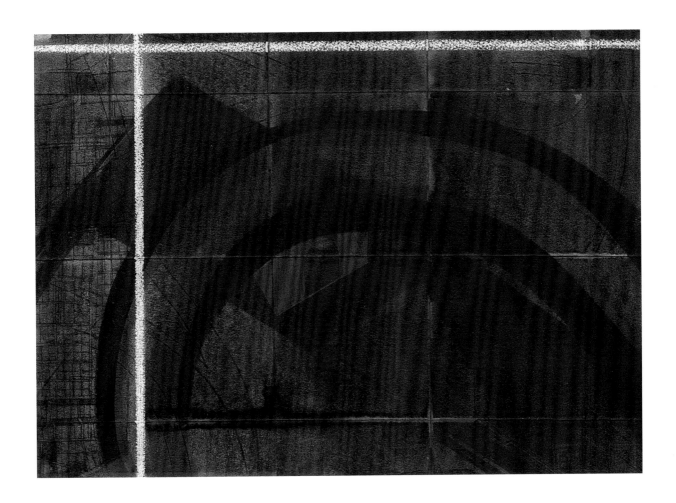

" *Line Tone Space Edge Surface Composition Scale Negative Positive*

Omit Add Grid Contrast Texture Pattern Weight Light Volume

Looking Seeing Collecting Finding Recording Noting Logging Remembering

Criticising Constructing Letting Go Concentrating Doing "

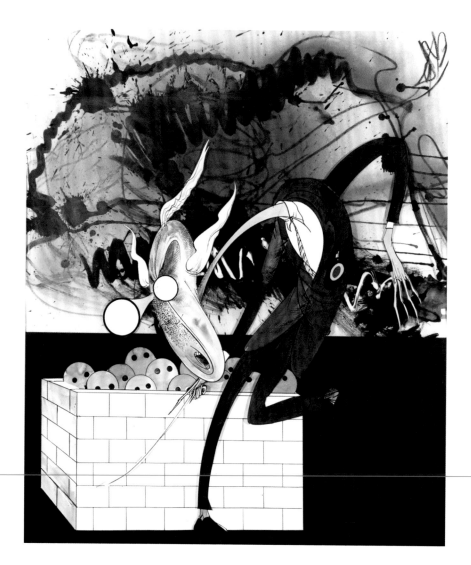

I Believe in
Good Old Drawing
Gerald Scarfe

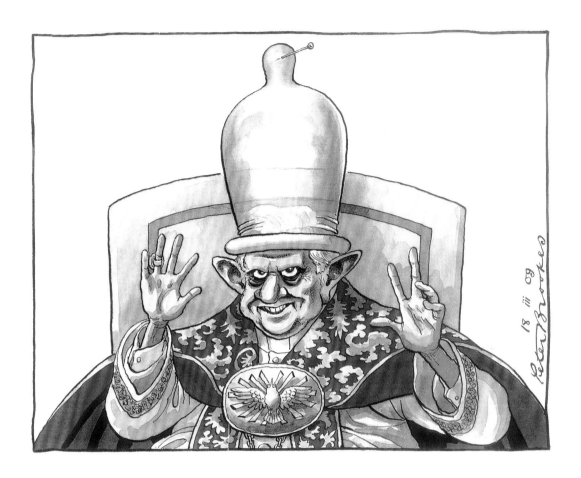

G.O.D., which Art in heaven …

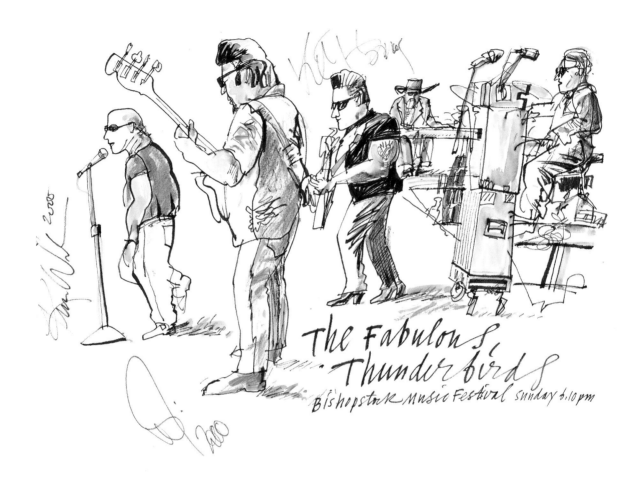

The Fabulous
Thunderbirds
Bishopstok Music Festival sunday 6.10pm

Drawing onstage
 the music is loud
 the crowd responds
It's physical
 I watch
and my pen dances across the paper

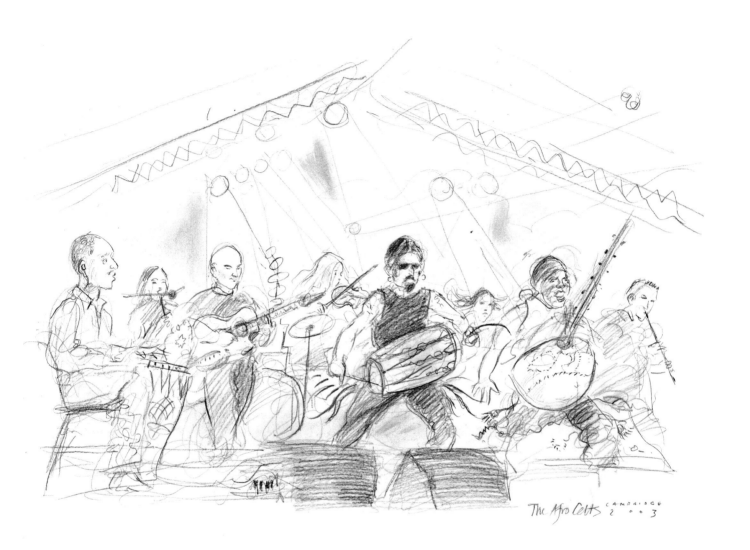

The Afro Celts CAMBRIDGE 2003

Cambridge Folk Festival - Main Stage

The press photographers are swiftly
moved on by 'security' leaving me to look,
listen and DRAW. With drawing you
can invent things, make changes or leave
stuff out. Drawers are not photographers.

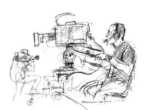

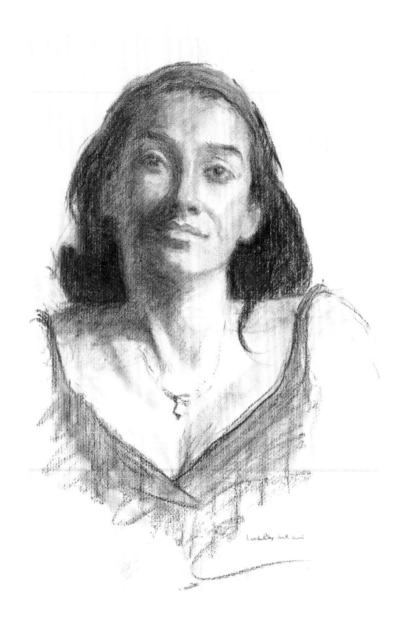

" G.O.D. - Of course I believe in good ol' drawing; it's the plan for a painting - map, grid, measure and check, proportion and perspective, like well-placed battements at the barre. And drawing is a line from the heart (if it's from the head it's dead); risk a line, naked and probably wrong, but if it leads from the heart it may be, just may be, art - drawing on the artist within."

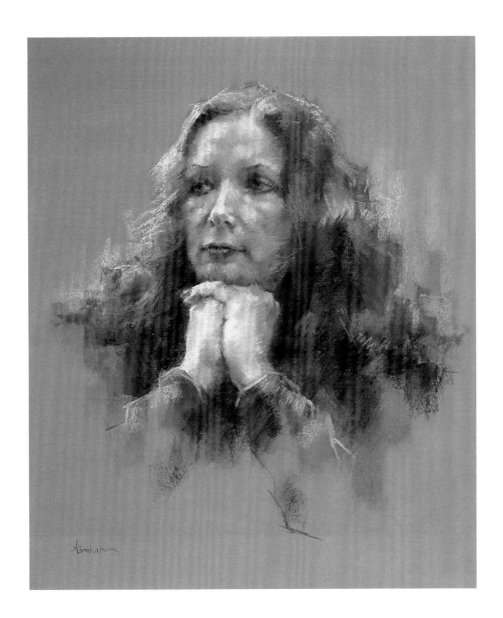

" *Drawing is like a journey in unchartered waters: each voyage is unique. And reaching landfall…?*
Not always guaranteed but always worth the trip. "

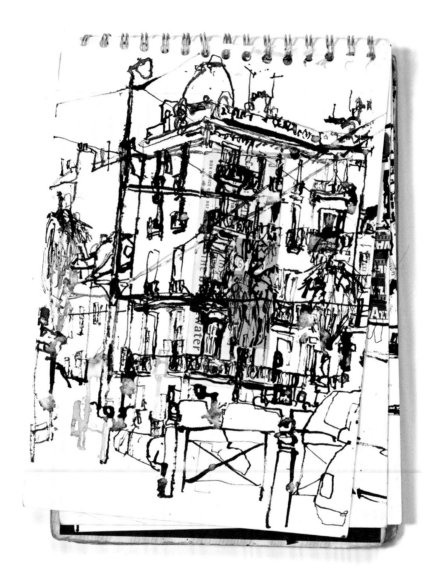

" *Marseille, January 2009 – a crisis of faith as the snow began to fall: should I place my faith in G.O.D. or in Ryanair? I parked my arse on the freezing roadside and started this drawing. The snow got heavier, 40 cm, the heaviest in living memory. Ryanair cancelled all flights and I eventually had to return from Marseille by train, but at least I now had this drawing.* "

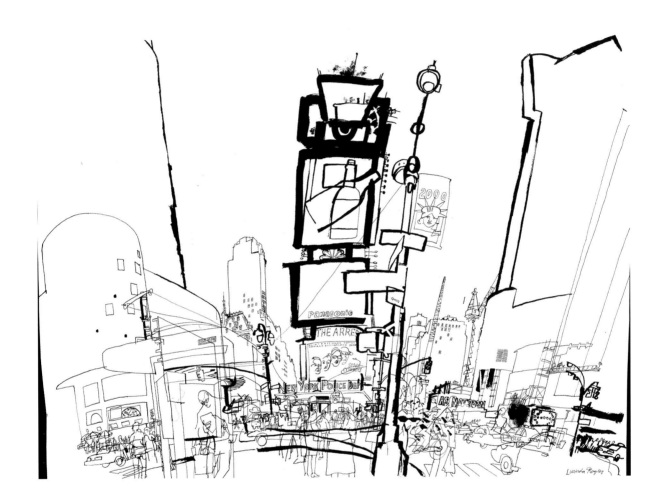

" *Drawing can communicate things that can't be transmitted in any other way.*
It joins up the conscious and the unconscious mind. "

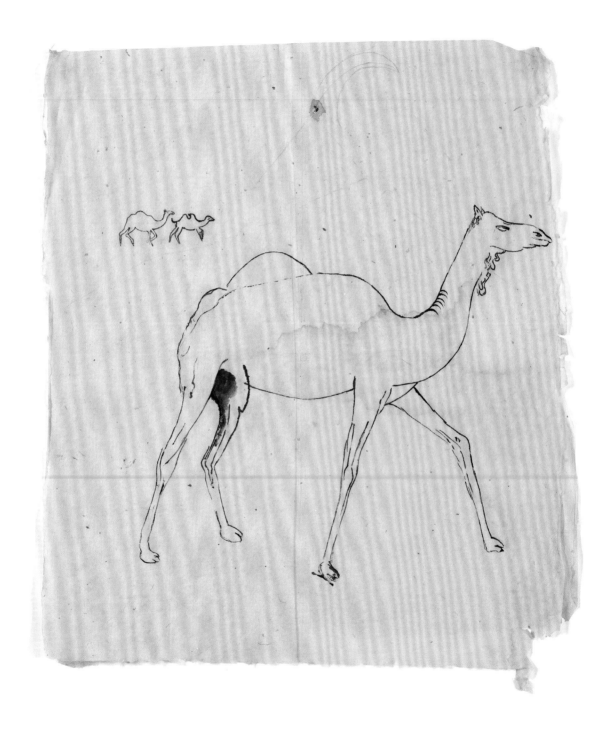

" If you can draw the human figure you can draw anything. "

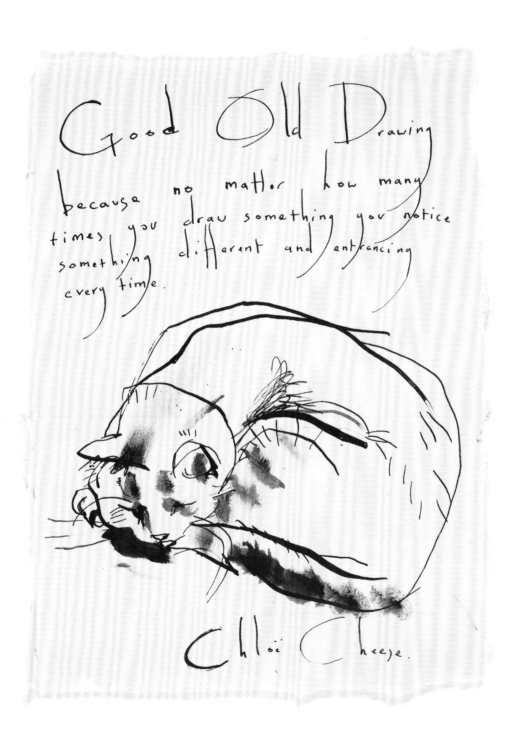

Good Old Drawing
because no matter how many
times you draw something you notice
something different and entrancing
every time.

Chlöe Cheese.

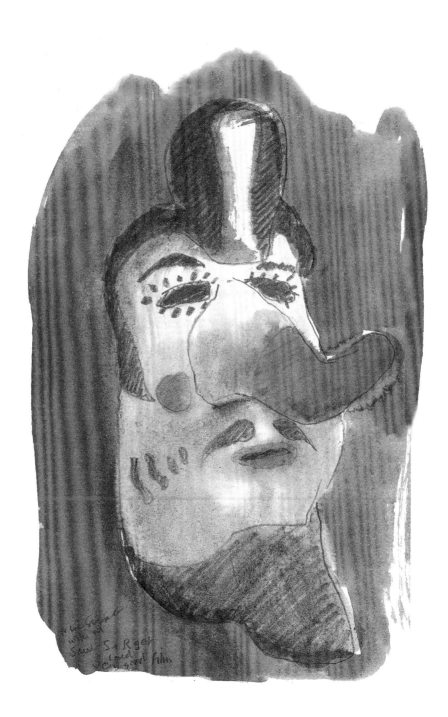

" *Before humans could make tools or lived in civilisations they drew.*
Everything we process, make, invent, depends utterly on some form of drawing – our futures
are useless and empty and meaningless without good old drawing. So get going – draw! "

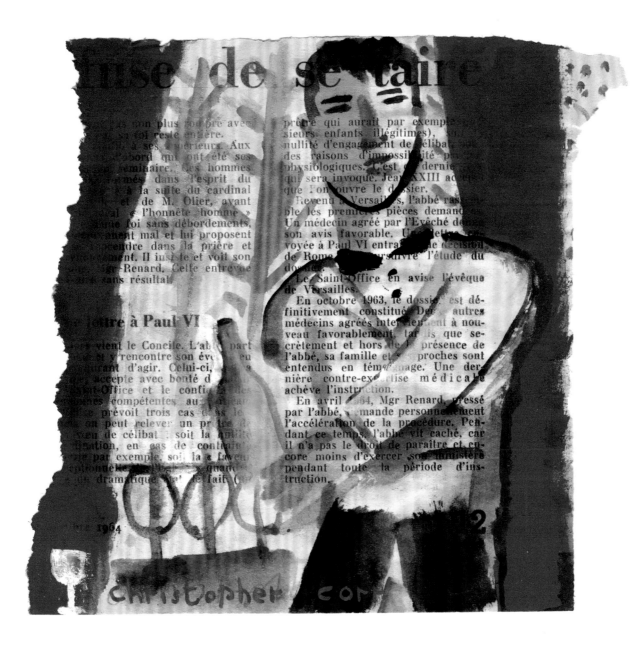

" *I have seen the world with G.O.D… I think that is my belief.* "

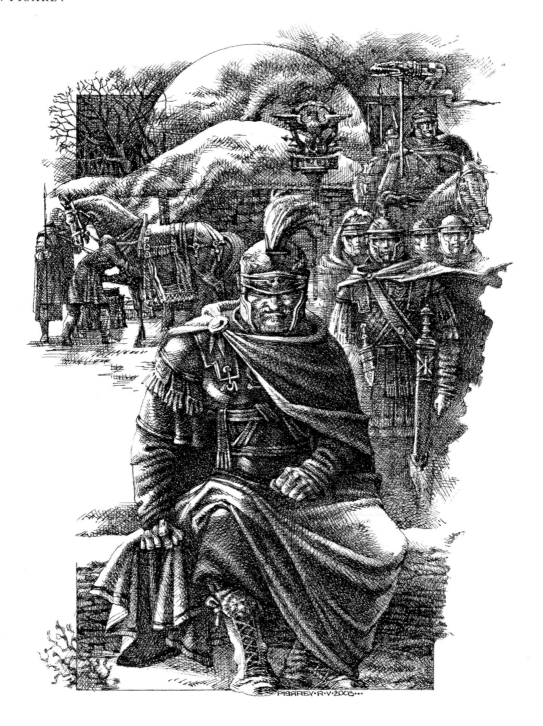

" *For me a great honour will become a part 'Good Old Drawing'!*
And certainly I BELIEVE, because am my religion since birth!!!!
Both My parents were strong artists, and probably prayed to same G.O.D. "

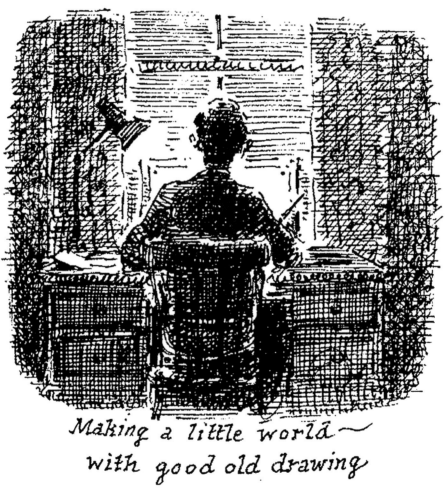

Making a little world —
with good old drawing

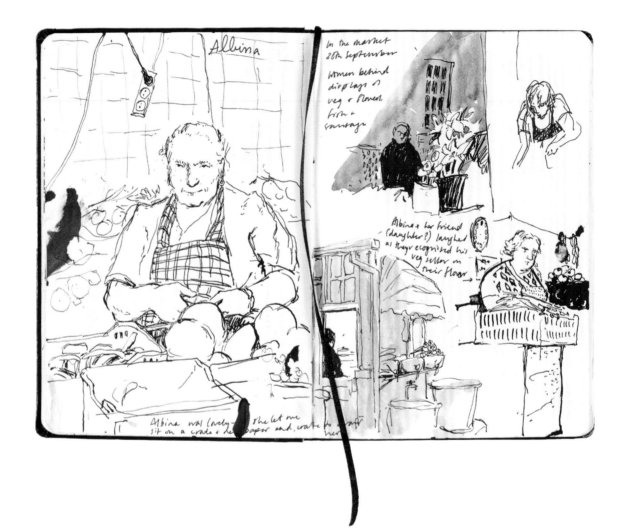

When I look back through old sketchbooks I am thrilled that I have kept drawing as the pages remind me not just of where I was or who or what I was drawing, but of snapshots of time - of trips out, where I worked and who with, what car I drove, what pubs I drank in, who my friends were and what music I listened to. But this is why I love sketchbooks. I think I believe in pure old, Good Old Drawing because it gives me the best excuse to stare at people.

" *…it is also surprising fun and is a great way to record and catalogue strange objects.*
Archaeologists still use it, instead of photography because you can edit information through drawings. "

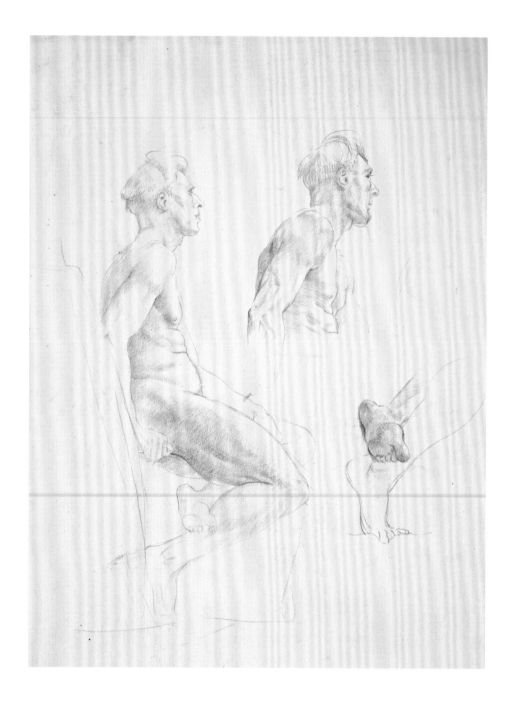

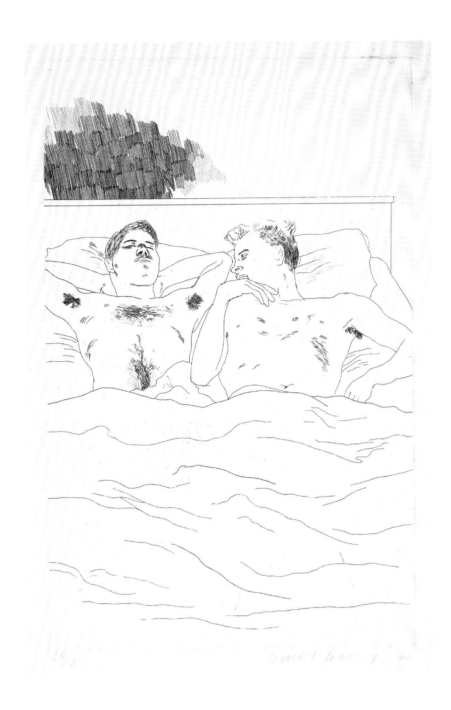

" *Drawing is a vital part of every creative process. It should be part of visual education in the same way that doing press–ups is part of an athlete's training.* "

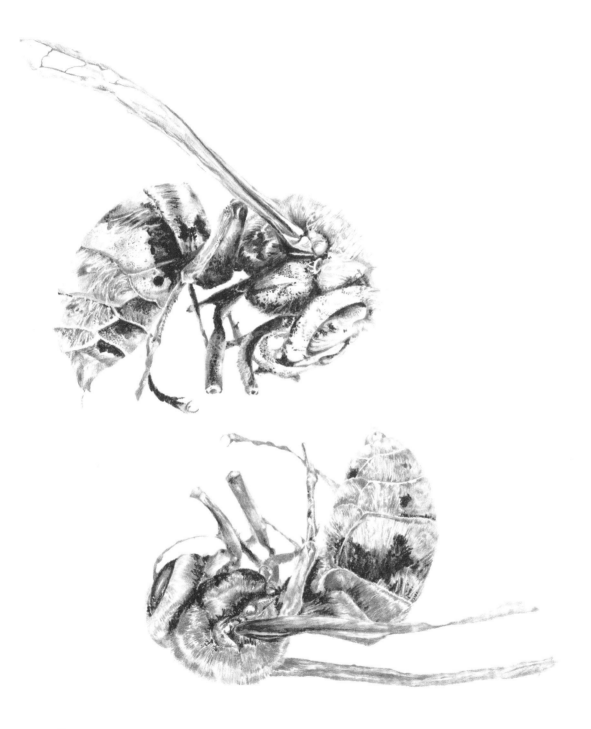

" *I believe – because when my mind is frantic and restless, absorption in Good Old Drawing brings peace and calm. It rewards with unexpected discoveries and renews my sense of wonder at the world.* "

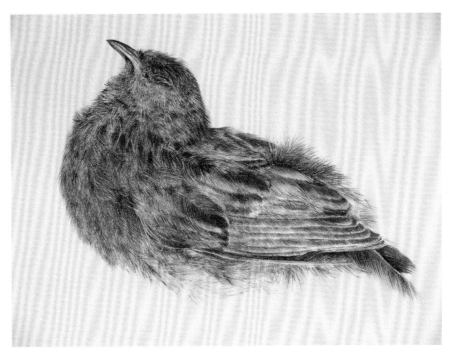

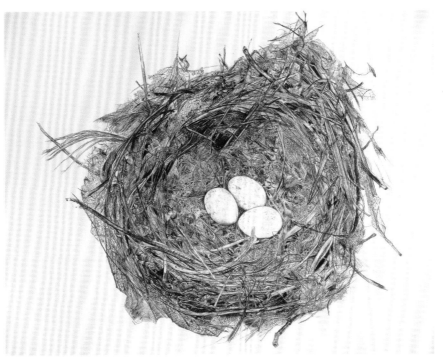

" Draw in G.O.D. in all things. "

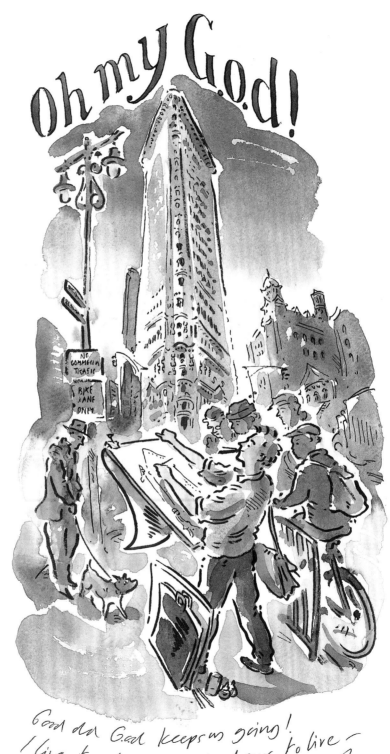

Good old God keeps us going!
I live to draw and draw to live –
Paul Cox.

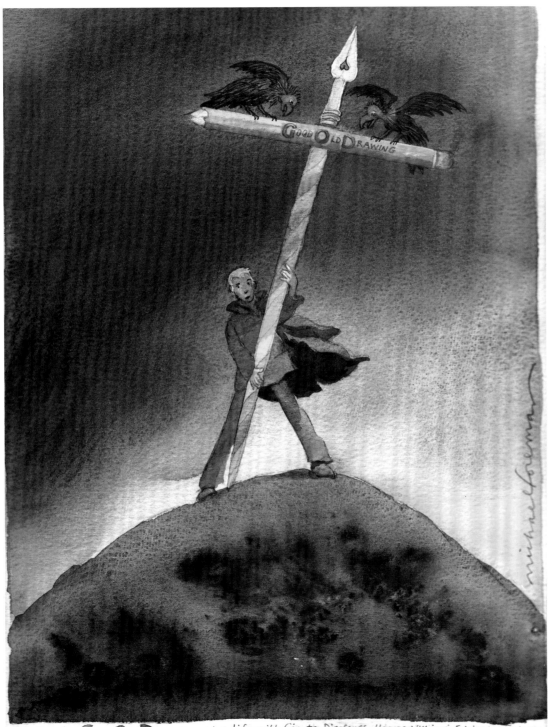

I believe in GOOD OLD DRAWING and a life with Giants, Dinosaurs, Heroes, Villains, Fairies, Monsters and everything imaginable.

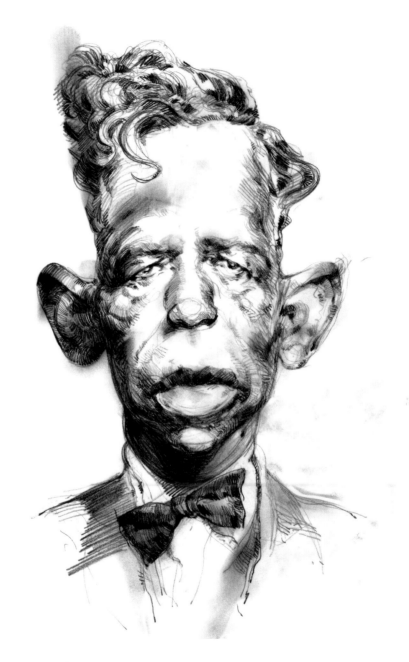

I can draw, thank G.O.D. —
... but I hope I never have to draw
a straight line to save my life !

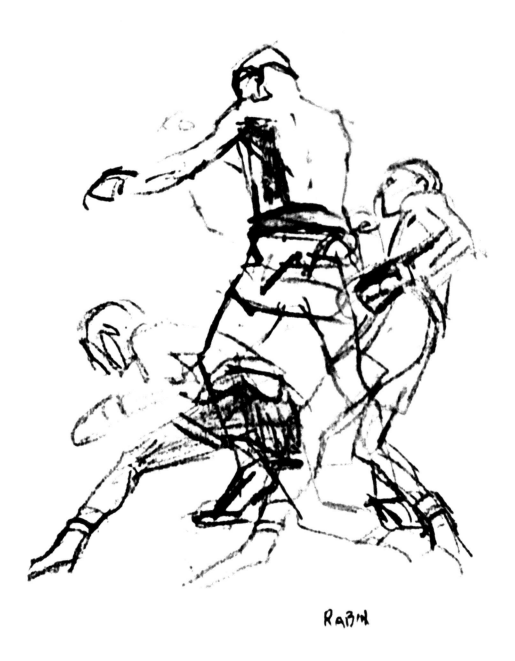

*" Shakespeare and the comic strip writer both use words but in very different ways.
Figure drawing provides the basic alphabet and discipline for whatever direction an artist
may take, from decorative illustration to abstract art. "*

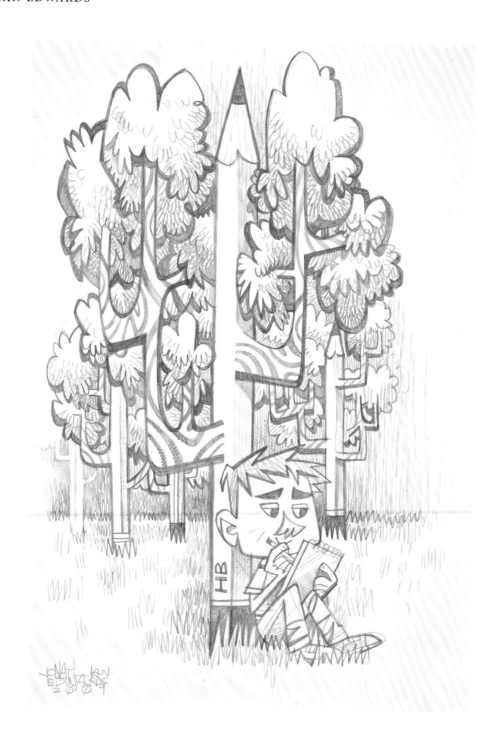

"*Whether you're using a pencil, pen, brush, mouse, stick dipped in mud or the soggy end of a breadstick, it's all drawing and drawing is good. I believe in Good Ol' Drawing.*"

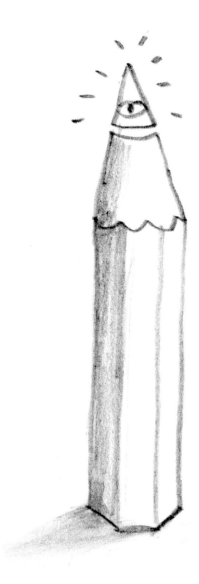

" Drawing is the foundation for everything I do, without it I wouldn't know where to begin.
My thoughts and ideas are usually difficult to articulate, but easier to sketch and describe visually.
Drawing is a very immediate form of communication and it transcends language, age and culture.
Children draw, long before they can write, some stop when they get older. "

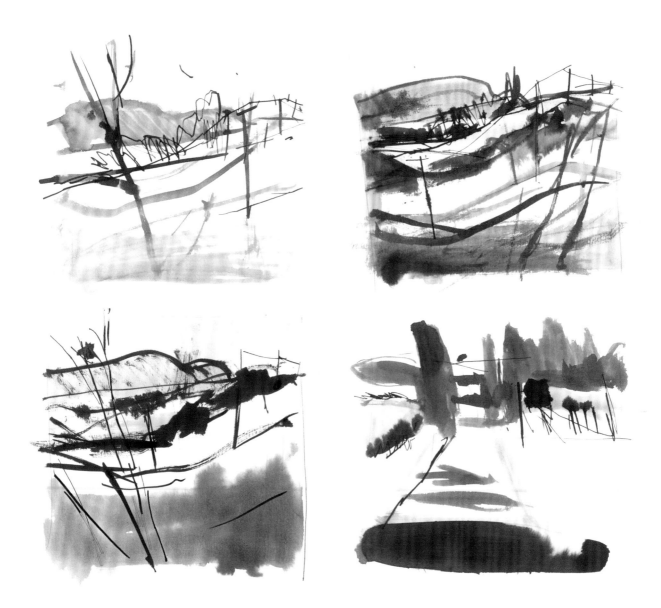

" *Good Old Drawing: everything starts here. Made with sticks, brushes, pens, whatever is to hand, these marks are the essence of my whole enterprise. They happen at every stage in the creative process of making my prints and paintings. Out in the landscape, back in the studio, how else to think, plan and interpret…*"

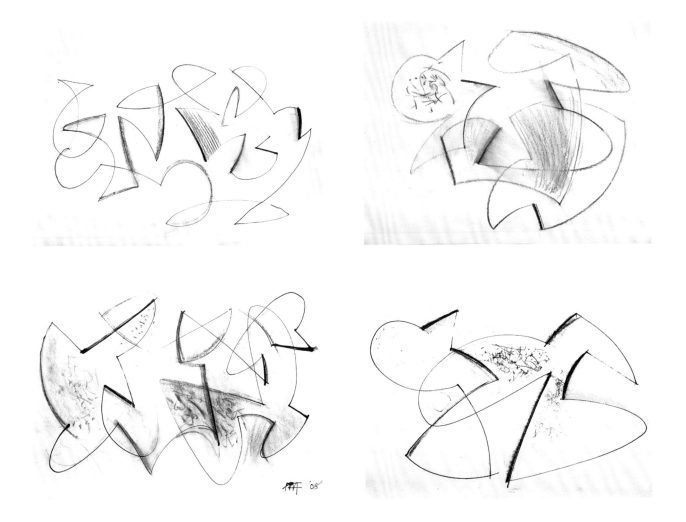

" *Drawing for me is the beginning of a process. Whether scribbles, sketches or more developed work. It is the first stage in the realisation of making a three dimensional piece of work, whether it's a ceramic shape or a mobile sculpture. The 'wind drawings' here were previous to dense clouds of shaped stainless steel wire, maelstroms of twisted angles and curves. I've often been asked why I don't use a computer for drawing – the reason is that when using a pencil, pen or brush the connections between hand, eye and brain are direct. To draw something either existing or imagined you have to be able to see it. A computer's visual perception is limited.* "

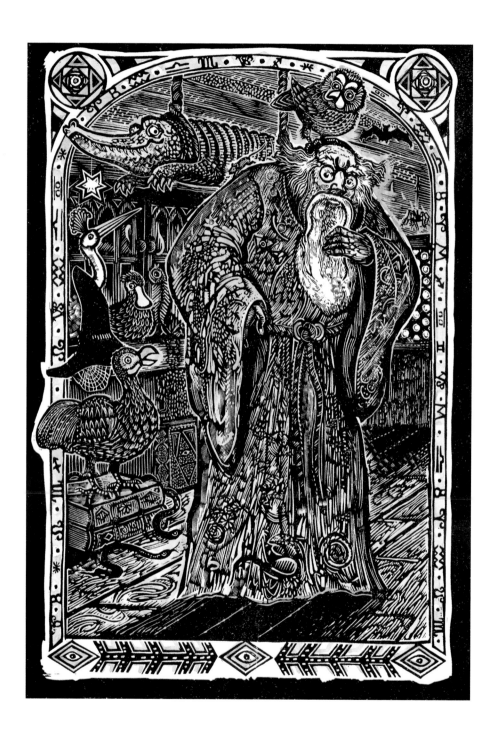

"*Good drawing is the basis of good wood engraving. The design is transferred onto the block in reverse and then redrawn. A drawing in reverse highlights any imperfections so the engraver can correct these before starting work on the block.*"

" *Right, here goes…*

If you can't draw, you're stuffed. The need to communicate is essential, and whether it be a scribble or a finely laboured 9B image, drawing employs an eloquence that sometimes words can never capture. I draw everyday. It can either end up as a Photoshop image or a screenprint, or a linocut, or remain a scribble. Drawing feeds into every part of my life, from doodling with my two bairns to paying the bills and it never fails to excite me. Taking it through a process like printmaking then adds to the excitement and now and then people part with their hard earned money. Then I buy more brushes, ink and paper to do some more drawing. "

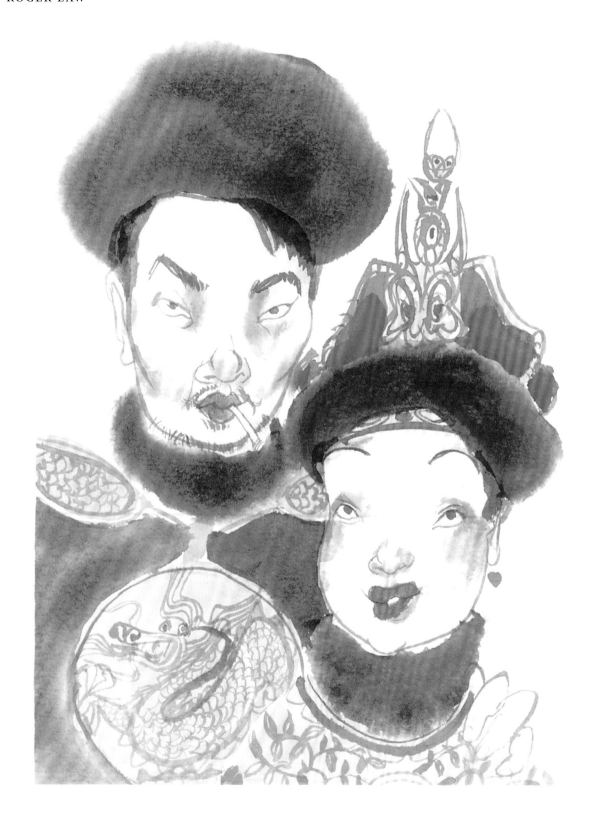

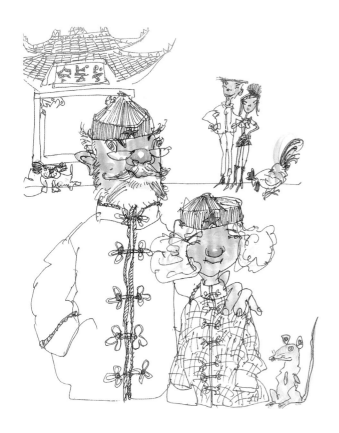

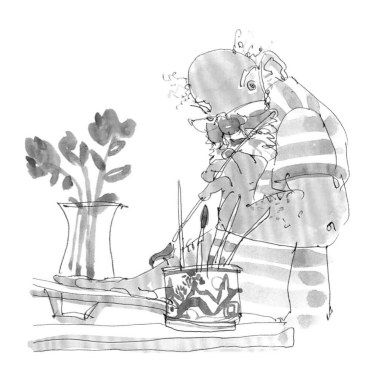

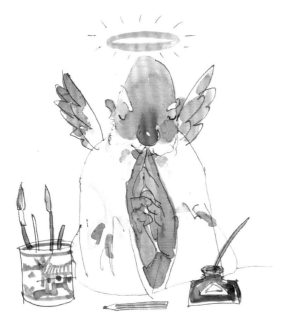

OUR DRAWING, WHICH ART A HAVEN
HALLOWED BE THY LINE
THY INSPIRATIONS WILL COME
THY SKETCHES WILL BE DONE
ON EARTH AND HOPEFULLY IN HEAVEN
GIVE US OUR DAILY DEADLINE
FORGIVE US OUR PLAGIARISMS
AS WE FORGIVE THOSE THAT PLAGIARISE AGAINST US
AND LEAD US NOT INTO COMPUTERISATION
BUT DELIVER US FROM BOREDOM.
FOR DRAWING IS OUR LIFELINE, OUR SURPRISE
AND OUR DELIGHT,
FOR EVER AND EVER, AMEN!

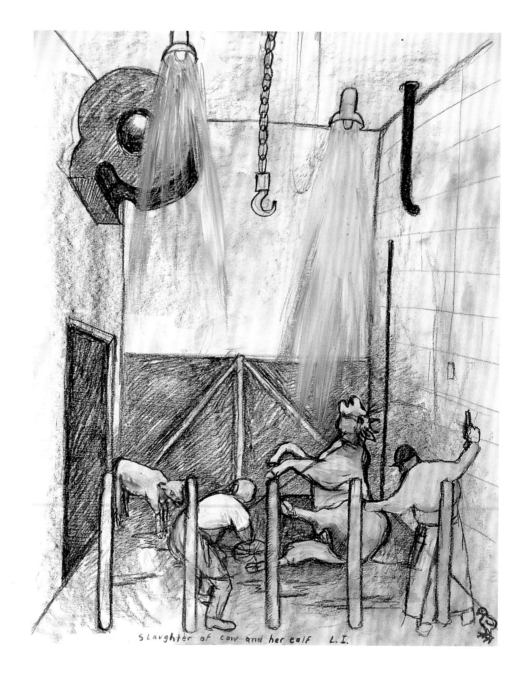

Slaughter of cow and her calf L.I.

" *Dear G.O.D., may you allow me to draw every day of my life,*
 and always carry a sketchbook,
 to record the ordinary and make it extra ordinary,
 to go where no camera or Photoshop has gone before,
 (or is allowed to go)

let the pencil shine a light on the unseen,
the concealed, the hidden,
follow the graphite line and the deep black on white,
elegance and simplicity are yours, dearest paper and pencil,
never forsake me. "

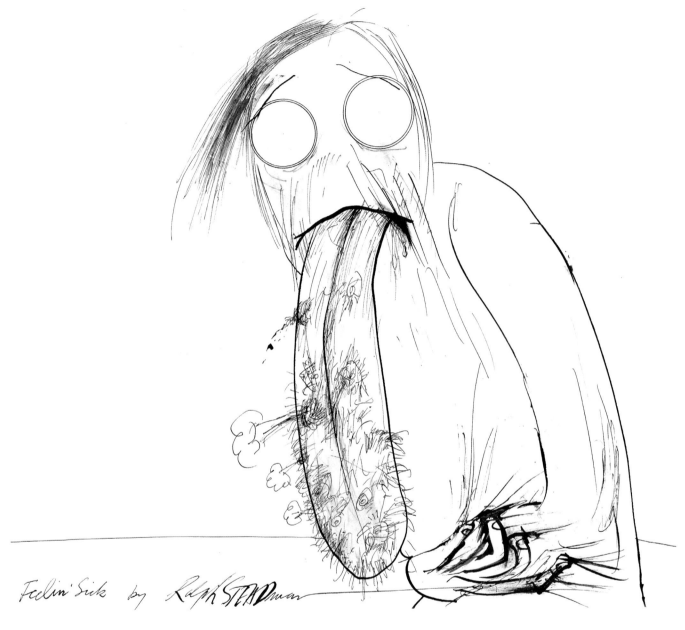

Feelin' Sick by Ralph STEADman

Drawing is a personal way of conveying a message..

Hi! GOD.!! — if you are there !!!?

P.S. I wonder if he's BALD ??!

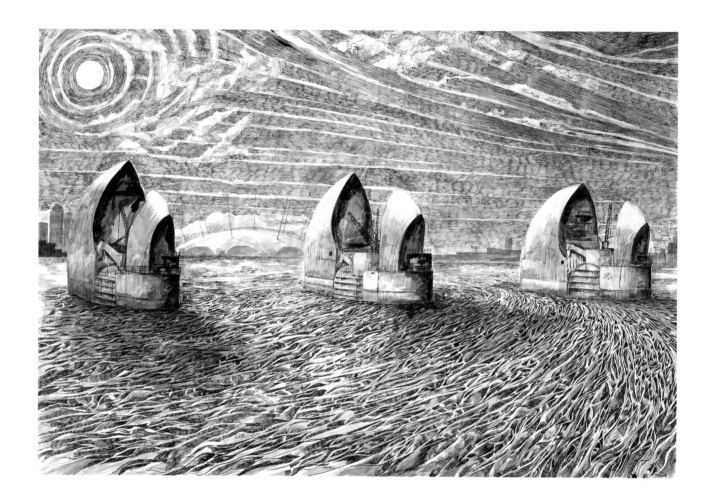

" *Why do I believe in G.O.D.? I have drawn ever since I was a child. For me drawing is the basis to everything that I do.*
Its a wonderful thing G.O.D. It's about looking and describing what you see, but also in my case from what is in my mind.
I have absolute faith in G.O.D., and too many people believe in it for it to die!!! "

I believe in Good old Drawing party because what I liked about it when I was a Kid still gives me a Kick = seeing the graphite melt onto the page — You Know that it's your own movement of the pencil and the pressure you're putting on it that makes the mark but still it looks like magic that it left a trail.

It's similar to writing in that way. Then, once you have learnt to represent people and put them in a believable space and world, you realise that you can arrange any whole scene as you see fit and to your own stage-direction — at least, that's what you sense may be possible and so your curiosity about what you might be able to do, there, Keeps you trying.

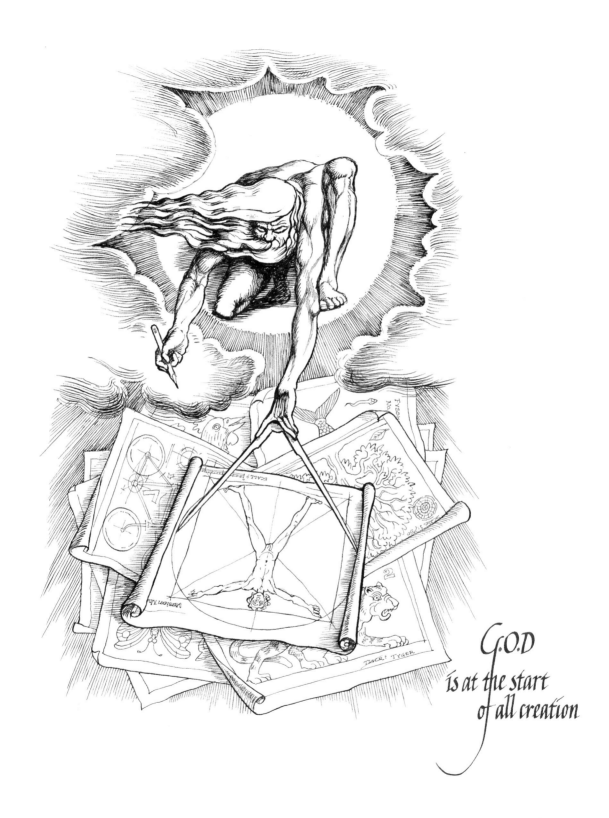

G.O.D
is at the start
of all creation

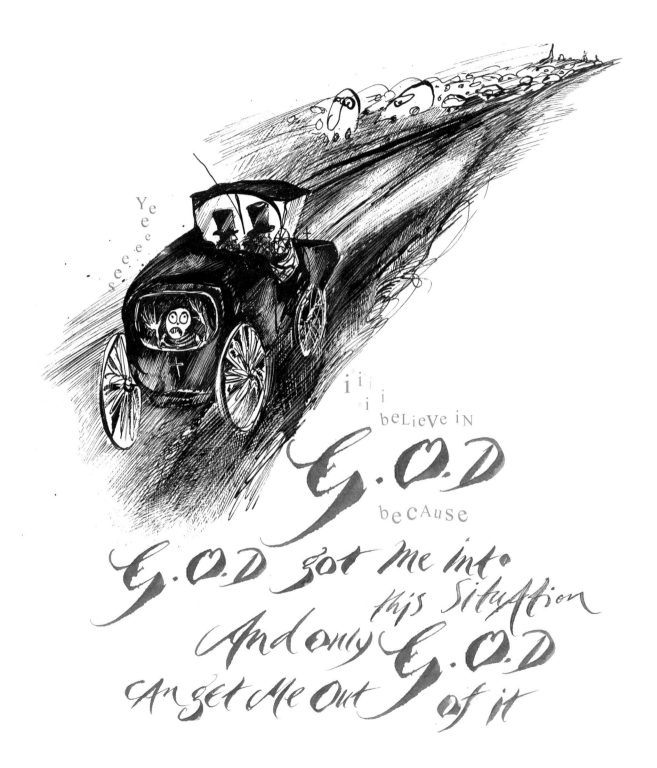

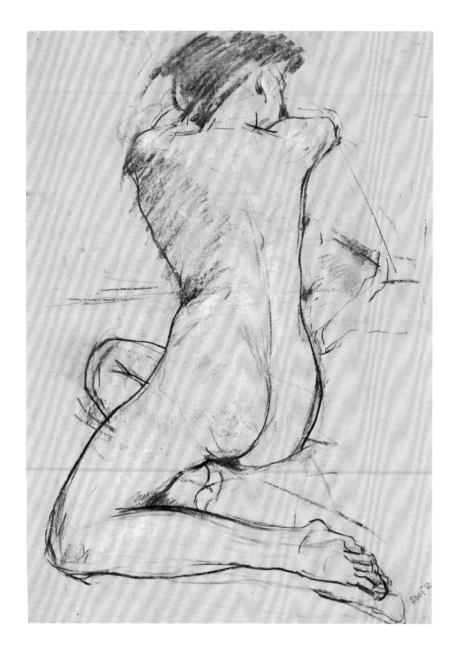

"*G.O.D. marks in mysterious ways.*
The smudgiest black of burnt willow,
The gimlet 10h for stone,
As soft line deep into clay,
Or a curve drawn on for carving.

I am fanatic for G.O.D. Destroy the
cheap rubbers that tear and smear,
And put our children off before school!

G.O.D. makes me happy.

G.O.D. gives me work.

G.O.D., because like Picasso
I too was crap at chemistry."

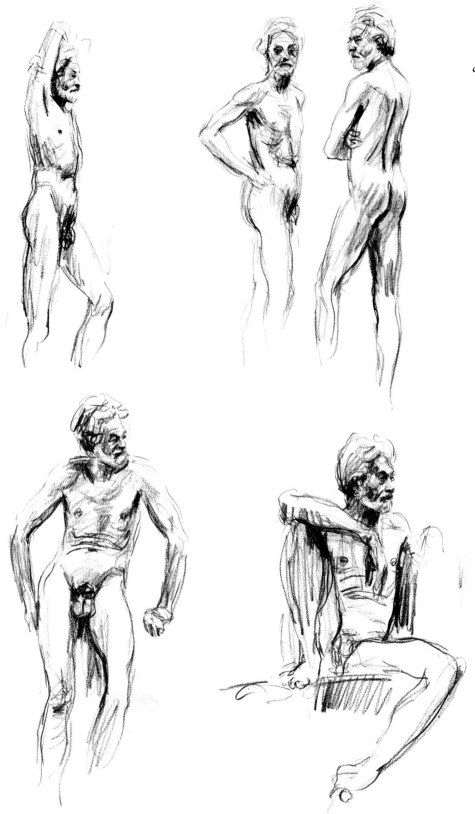

" *Continue to be thrilled by the sheer virtuosity of great drawings – every millimeter of every line loaded with intelligence, originality, abstract beauty and sensitivity, and at the same time pulling off the magical trick of superbly conjuring up a description of the world…*

Love the Zen approach to art: simplified to the bare bones of black paint and brush – no hiding place, direct, spontaneous, playful, iconoclastic – the collapse of painter, painting and painted into a oneness of utterly fresh 'is–ing', paradoxically including all the personal, quirky, conditional… Art, not as pedagogic pointing, nor an expression of Zen – just Zen itself, presence awareness, life, Tao, God, Celebration…

…Just birds singing their songs… "

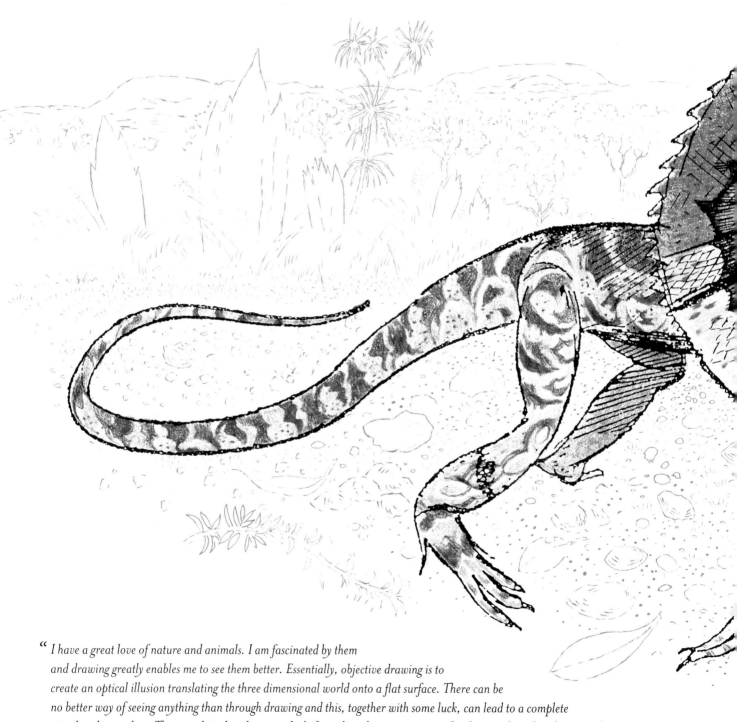

" *I have a great love of nature and animals. I am fascinated by them*
and drawing greatly enables me to see them better. Essentially, objective drawing is to
create an optical illusion translating the three dimensional world onto a flat surface. There can be
no better way of seeing anything than through drawing and this, together with some luck, can lead to a complete
visual understanding. The tragedy is that there is so little formal teaching in most art schools nowadays. In relation to drawing
I think it would be difficult to better William Blakes lines from Auguries of Innocence,"To see a world in a grain of sand, and heaven
in a wild flower, hold infinity in the palm of your hand, and eternity in an hour." "

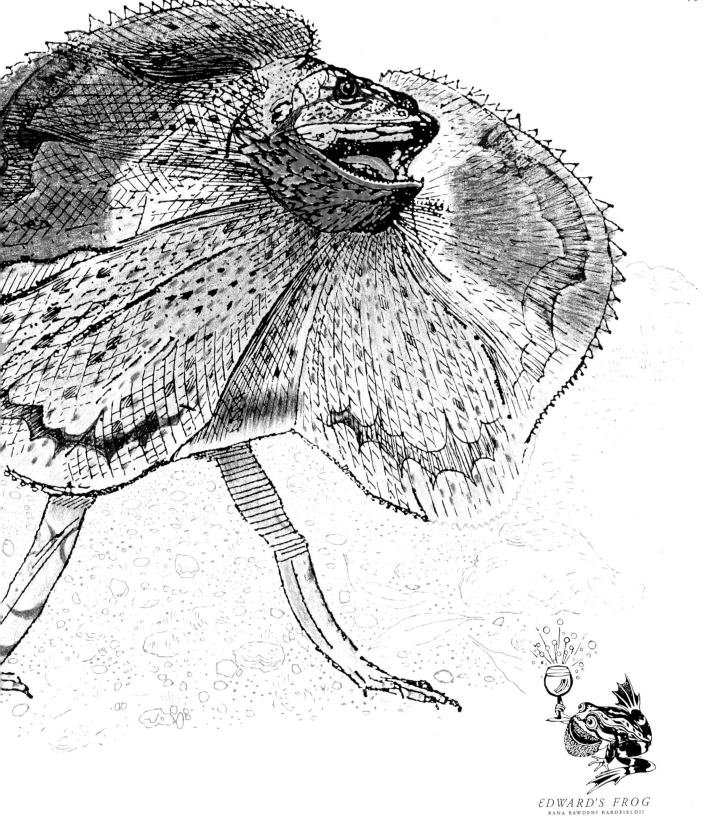

EDWARD'S FROG
RANA BAWDENI BARDFIELDII

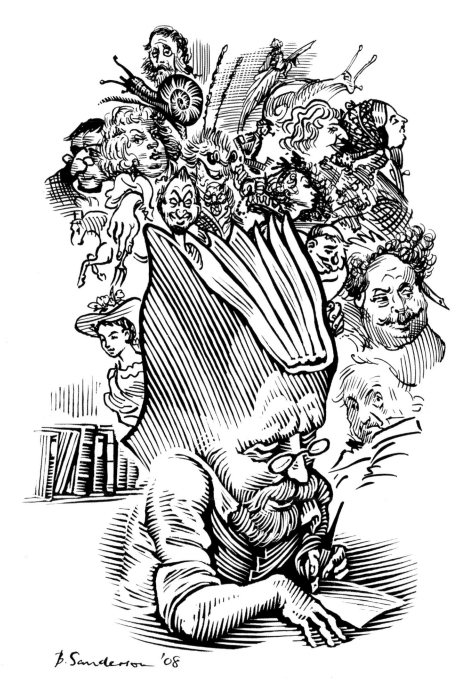

" *Drawing inspiration from a bookshelf – Bewick, Caldecott, Cruikshank, Daumier, Doré, Doyle, Du Maurier, Eisner, Fraser, Gentleman, Gill, Gillray, Grandville, Guys, Hassall, Heath, Kley, Leech, Leighton, May...*"

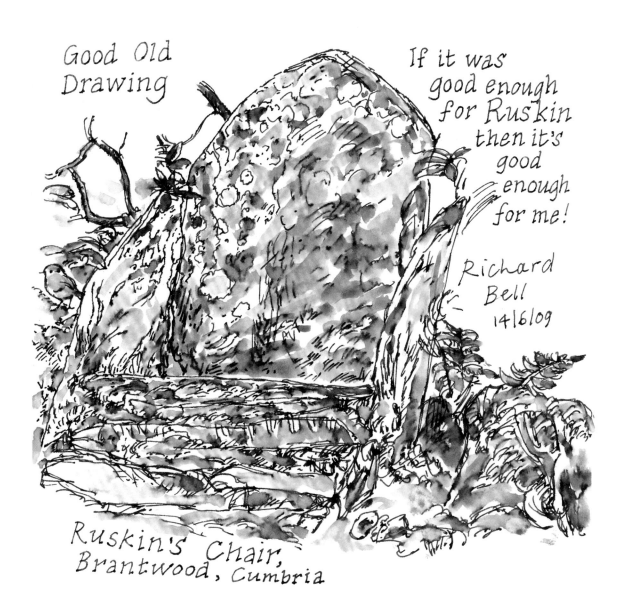

Good Old
Drawing

If it was
good enough
for Ruskin
then it's
good
enough
for me!

Richard
Bell
14/6/09

Ruskin's Chair,
Brantwood, Cumbria

inferences & conclusions

the_____somewhere

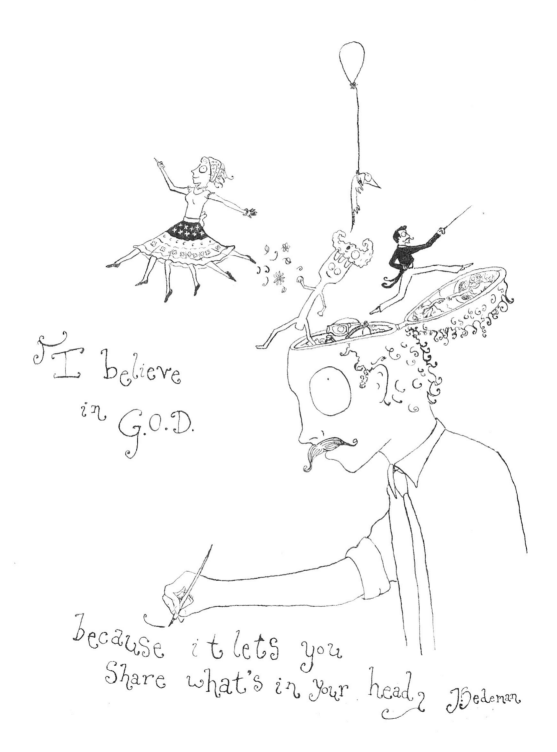

"I believe in G.O.D.

because it lets you share what's in your head. Bedeman

"Q. Who made me? A. G.O.D. made me."

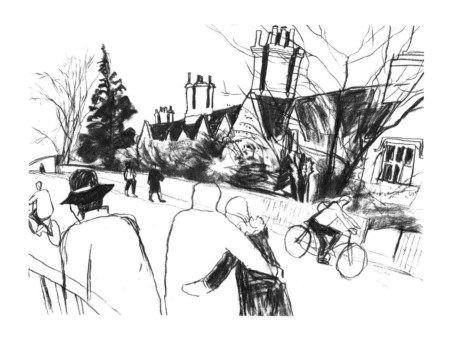

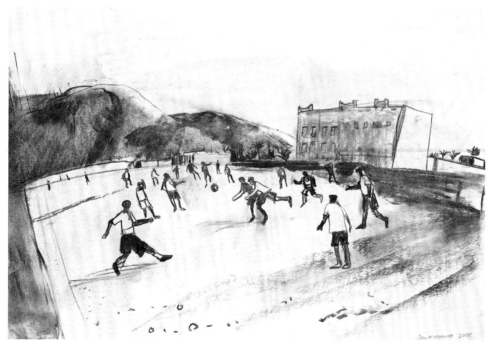

" I love Drawing (Good Old Drawing)! The line is a lifeline for that sinking feeling and hauls you back onto safe ground. No line is lifeless – let it free to capture the moment fast and fleet which will never come again. "

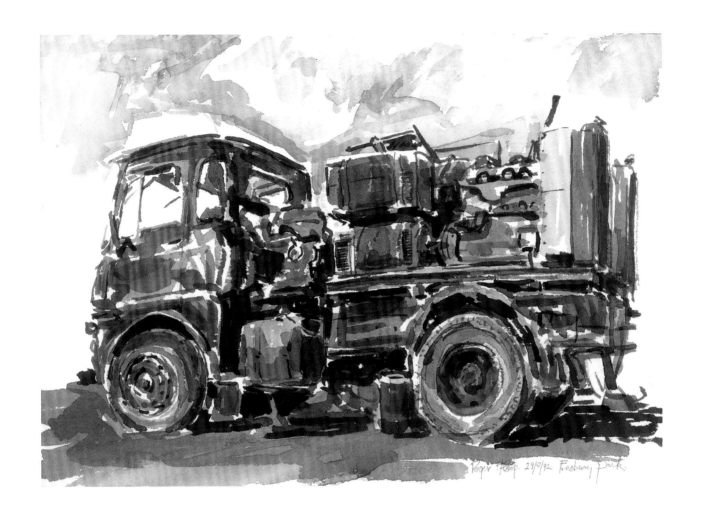

" *I remember when I was about five years old I stood at my father's knee and watched him make a drawing with a pencil and a sheet of paper. He worked for a few minutes and suddenly something lived on the page. From nothing he'd created a kind of life. I felt that this was a sort of magic. It was alive. It gave off energy. From that day on, I've never lost that sense of excitement. And that's why I believe in G.O.D.* "

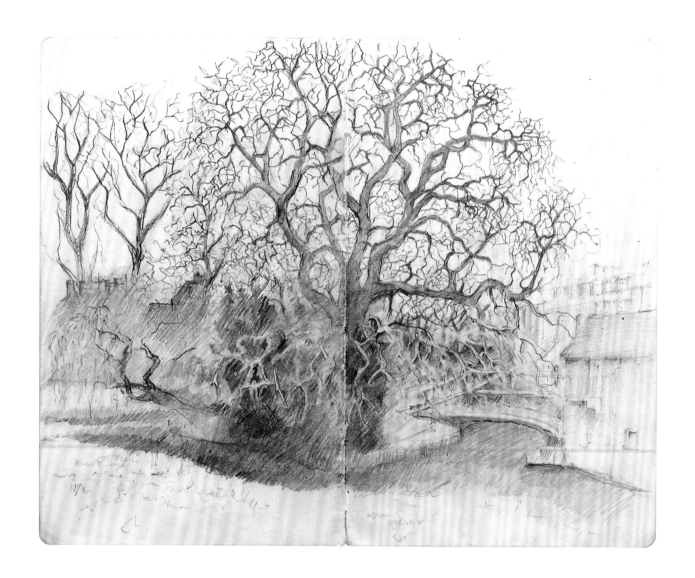

" *I believe in good old drawing because when I have paper and pencil I am never at a loss for something to do.* "

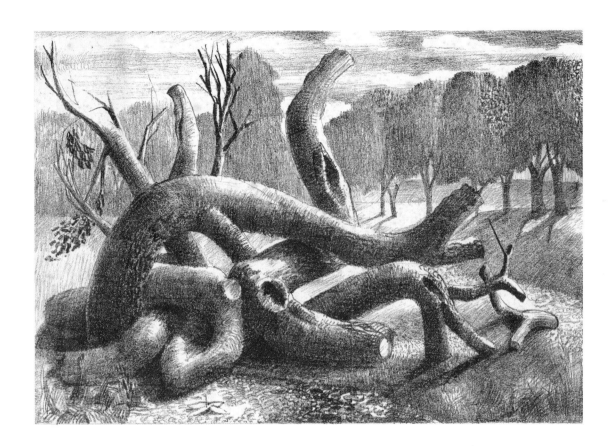

" *John was the teacher on my first day at art school. Later I worked for him when he was head of the Cambridge School of Art. If he ever caught a student empty handed his castigation would be "What, no sketch book!"* " JOHN HOLDER

"*Drawing is hard, and that makes it so challenging and rewarding. We all, as children, expressed ourselves with observations on paper, it was an exercise in communication, a reason for looking closely at people. The physical qualities of pens, pencils and paper are sensual and delicious, and for an onlooker, watching an artist at work, magical.*"

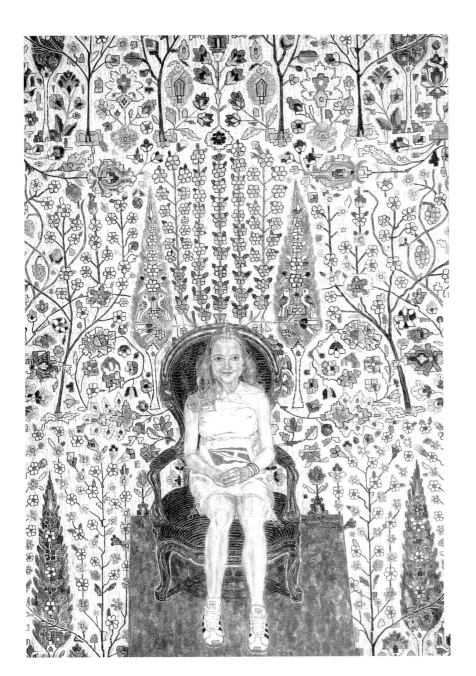

'Energy is Eternal Delight'
 William Blake

Drawing is a searching selection to
discover the unique shape and the
internal energies of natures living
forms in space.

In this respect everything I draw
is a portrait, be it a snowdrop, a
mountain, a human head. To
do so successfully, one must create
an abstraction a visual equivalent
for natures energies.

I love the sensuous contrasting various
drawing medias and papers available.

To create an equivalent, touchable
presence in a portrait, still life,
landscape drawing, or painting,
vibrating in differing degrees of
light and shade, is very difficult.
I am still trying.
 Dr Leonard McComb RA.
 12 · 12 · 2010

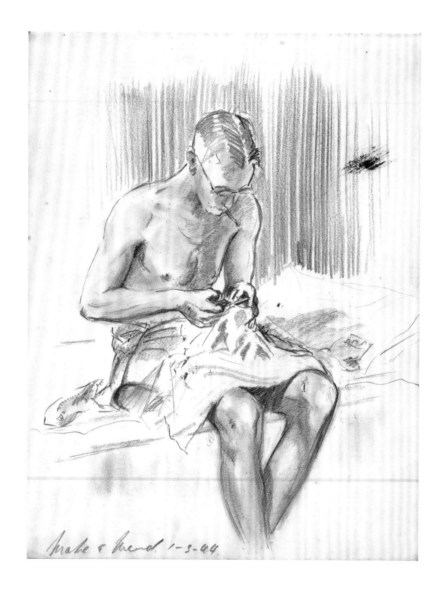

shape & head 1-3-44

" *Over his long life, John kept up the practice of observational drawing, and the underlying structures of the physical world –*
natural forms, buildings, machinery, people – gave his work a sense of permanence through form and mass. He had a huge
respect for the traditional principles of draughtmanship, and for the artists who demonstrated those skills. John was also
concerned with capturing the fleeting, everyday world around him, constantly drawing from life, equally interested in family or
flowers, clouds or people, faces or animals. Perhaps it was the practice of drawing that helped him acquire the skills he needed
to capture the transient. This was, I think, what made him a natural teacher; he understood this stuff, so he could explain it. "

AMANDA HALL

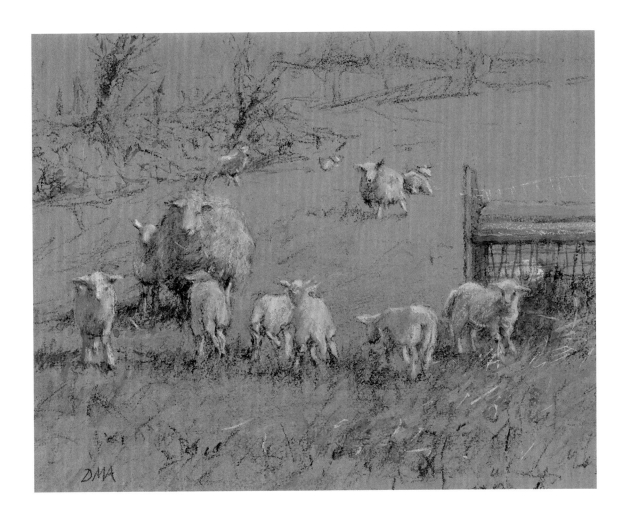

" *Drawing is the best and most enjoyable means of studying the visual aspect of subject matter. From minute to minute the subject reveals itself and far beyond the purely visual. There are few activities so deeply absorbing, so nourishing to the spirit. I do have to add, especially when the drawing succeeds in expressing what one has learnt and come to appreciate in the subject. It does take time and endless practice to develop an eye that can see every day and a language of drawing that can be relied on. There are few of us who can be sure of calling up the necessary faculties, eye, mind and hand together, everytime, but the effort is enormously rewarding.* "

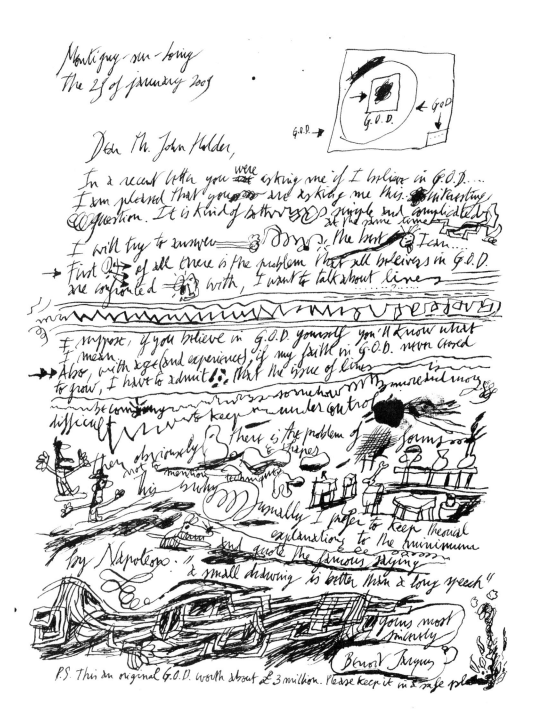

Montigny-sur-Loing
The 25 of January 2005

Dear Mr. John Holder,

In a recent letter you were asking me if I believe in G.O.D....
I am pleased that you are asking me this interesting question. It is kind of both... simple and complicated at the same time.

I will try to answer... the best I can...

First of all there is the problem that all believers in G.O.D. are confronted with, I want to talk about lines...

I suppose, if you believe in G.O.D. yourself you'll know what I mean... with age (and experience) if my faith in G.O.D. never ceased to grow, I have to admit that the issue of lines is somehow more and more difficult ... to keep under control. There is the problem of forms & shapes. They obviously... not to mention technique... his ... Usually I prefer to keep theorical explanations to the minimum and quote the famous saying by Napoleon: "a small drawing is better than a long speech"

Yours most sincerely
Benoit Jacques

P.S. This an original G.O.D. worth about £3 million. Please keep it in a safe pl...

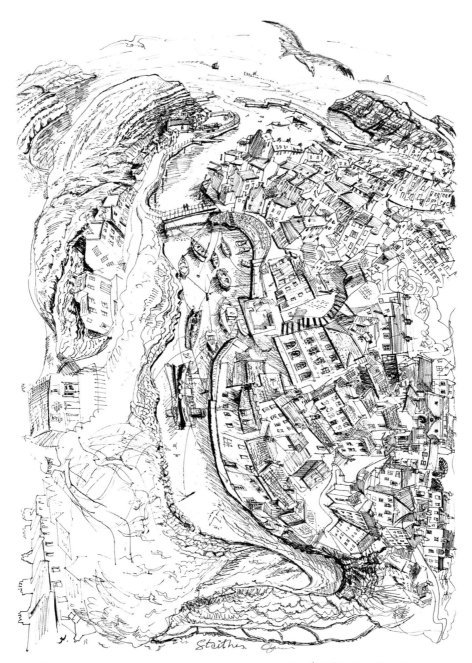

Staithes

I feel very privileged to have attended Cambridge Art School in the 60s
when drawing from observation was an important part of the curriculum.
This has been the foundation of all my working life —
it is said that seeing is believing; my belief is that drawing is seeing.

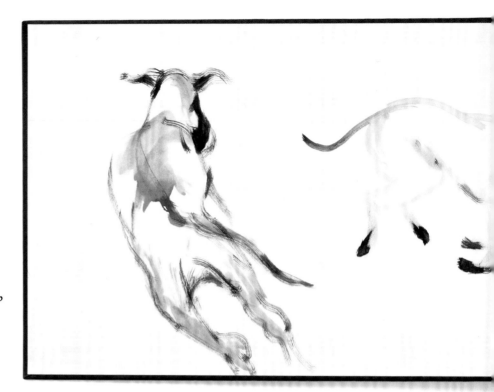

"*Drawing is like standing naked in the spotlight. It can reveal so many things about the artist – mood, personality, attitude and, most importantly, ability.*"

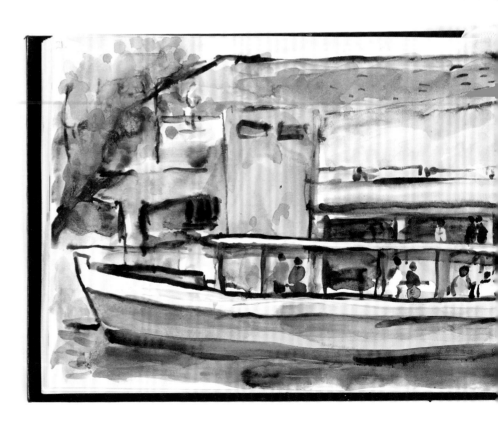

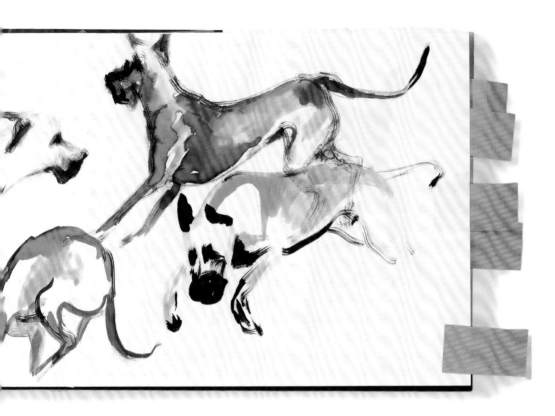

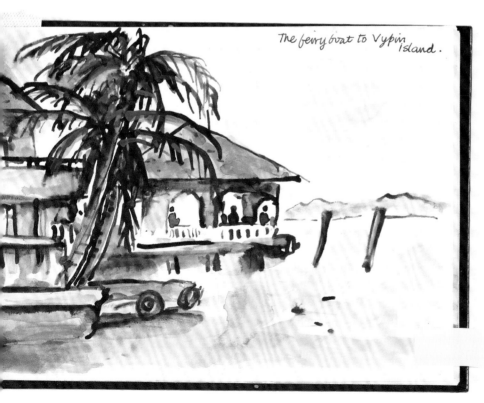

The ferry boat to Vypin Island.

"Almost all my drawing is in sketchbooks, either a studio notebook kind or a carry-around one. For me, the feature is not having any idea what is going to come out of it. At any moment I choose either to persevere or turn over another page. So, my commandment is…when things get in a mess, turn over a new leaf and start again."

Good Old Drawing ~ one of lifes simple pleasures...

Jane Ray

" *I keep a close watch on this art of mine,*
I keep my eyes wide open all the time,
I keep the pens out for the eye that binds,
because you're mine, I draw the line. "

(with apologies to Johnny Cash)

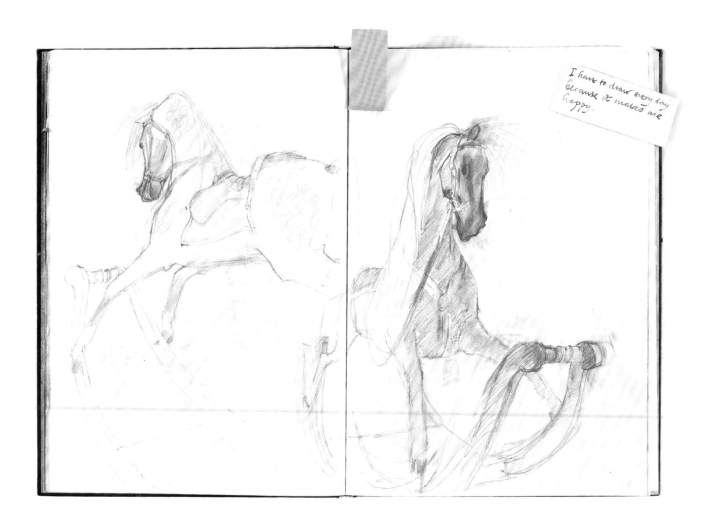

I have to draw every day
because it makes me
happy.

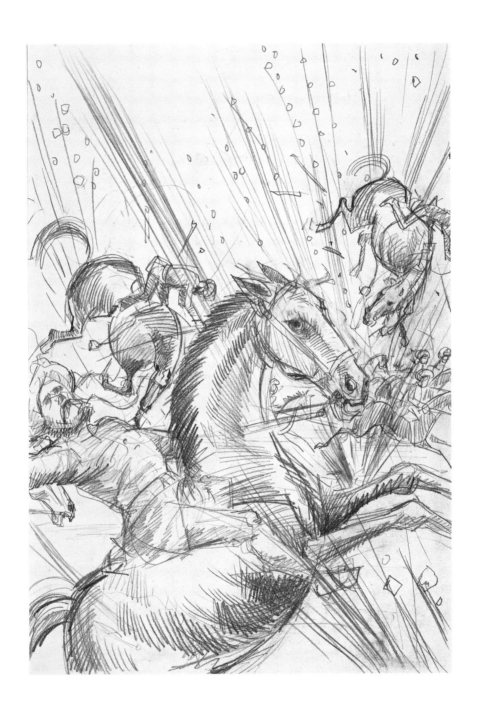

"*Why do I believe in G.O.D? It's putting life on paper isn't it? What could be more GOD-like?*"

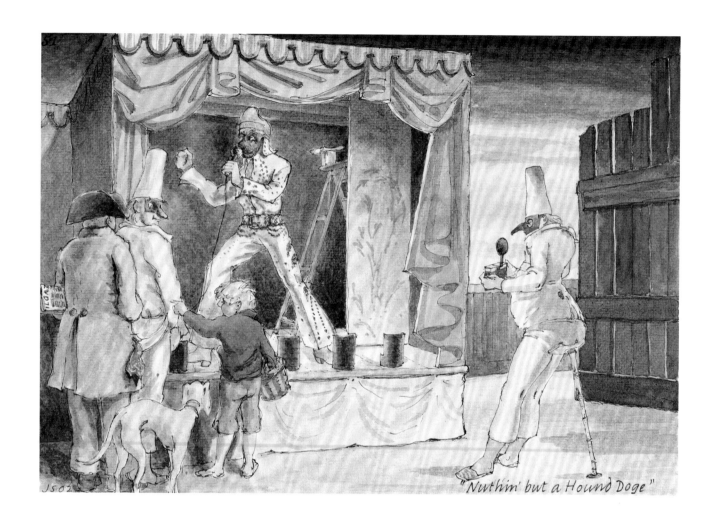

"Nuthin' but a Hound Doge"

" *Students of architecture at Cambridge in the Sixties were advised to think with their pencils and draw with their heads. This probably sounds deeper than it is – I think the point is that thinking and drawing are all part of the same process.* "

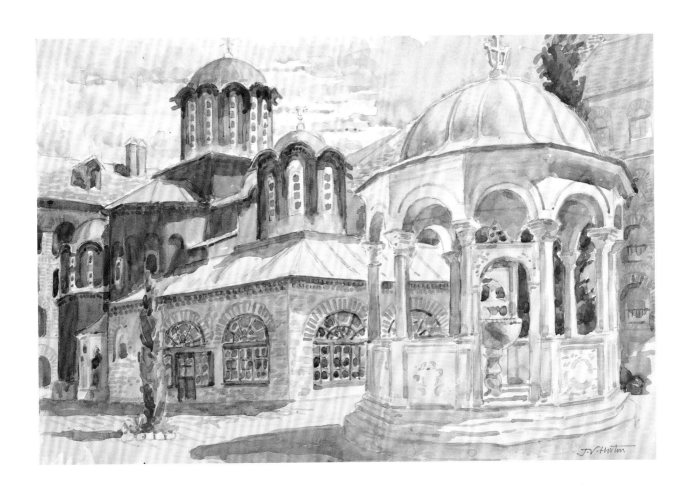

Drawing has been a major part of my life for just about all of my life!

For me, the act of drawing is both one of the most enjoyable of activities but also one of the most intellectually stimulating.

It gives me the most enormous pleasure to sit and draw and embrace a complex piece of architecture — equally the human form has constantly occupied my thoughts and ambitions as an objective, figurative artist.

Perhaps one of the most sobering thoughts is that in these days of high technological achievement and constant advances on an almost daily basis, the act of drawing has remained unchanged, in essence, almost since the beginning of time. There is fundamentally no difference — no advantage or disadvantage to when I sit down to draw with a piece of chalk or charcoal or when a Renaissance artist of 500 years ago began to draw.

I really like the idea of that.

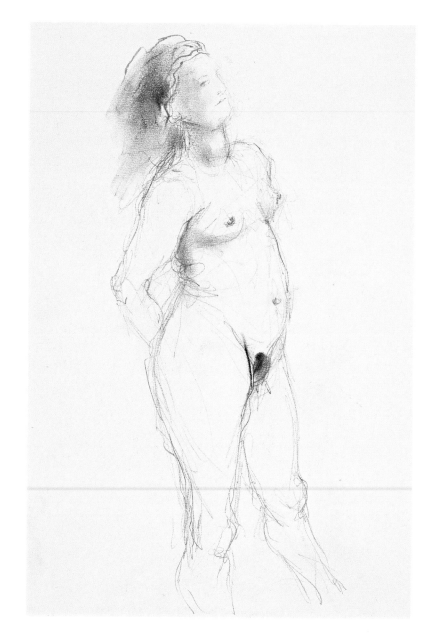

haiku (for . g.o.d)
Black-fingered girls eye the moon;
a life-line slips across
the snowy plane.

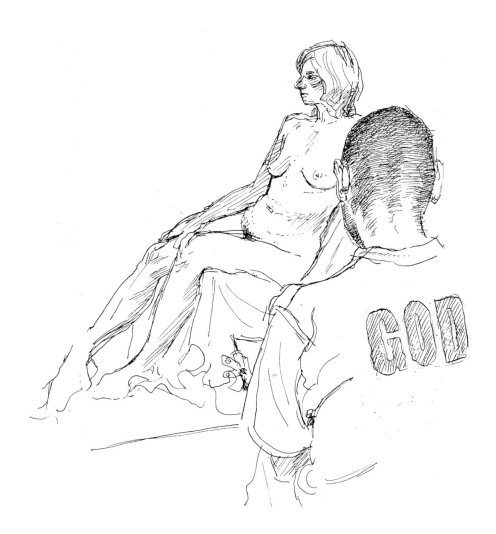

"*Actually I'm not sure that I do believe in 'Good Old Drawing'. It's a handy acronym*
but the phrase suggests something ancient and in need of resurrection or preservation in aspic,
rather like Prince Charles's awful, misguided Poundbury village. What I believe is that
good (old or new) drawing is as vital and relevant in the digital age as it ever was. Drawing is seeing.
Drawing is thinking. And good drawing is understanding. We live in an age where speed and economy rule.
A loosely connected series of buzzwords can be mistaken for meaning or content.
Terms such as 'visual literacy' are bandied about promiscuously, usually referring to a
superficial skill in decoding visual metaphor into words. If 'literacy' means to read and write,
'visual literacy' must surely refer to the ability to see and draw. What you then do with it…
well that's the interesting bit."

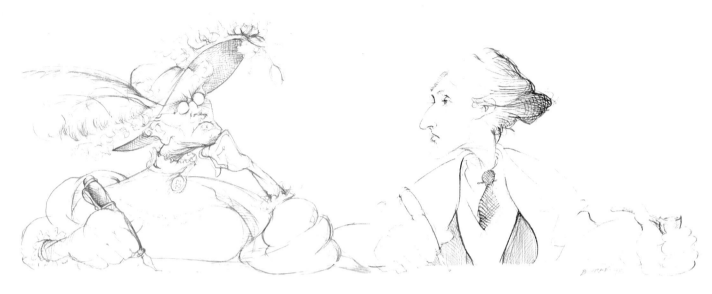

I was lead from the DARK,
drawn to the Light...
Was bland but now I see.

Draw your own conclusions

Chris BURKE '10.

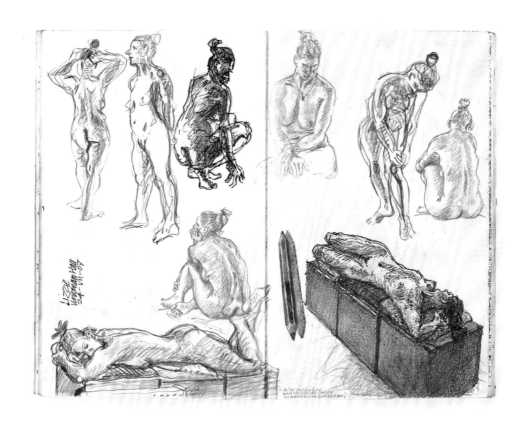

Do I believe in G.O.D? Belief is commitment, I've always been bad at tying myself down. But it comes creeping up on the elderly me that I've always been paid-up; whenever at school or home there were awful tasks to be done, Logarithms, Latin, muddy football, Bible Reading Fellowship or border-weeding, there was always an exercise book or lined pad under the desk on my knee — at the risk of being caught and bawled at, or being hauled out into the class by the ear. Drawing got me through school! Later, I found that some chores could be made into acts of drawing — as lovely George Herbert says, Who sweeps a room (as for Thy laws) Makes that and the action fine; and if pushing a broom about, or guiding a lawnmower, isn't an act of drawing, what is? But pushing pen or pencil around is better still: it puts the highlights and firm arrises and dimensions onto the room, or the lawn, and brings out the music. Now there's belief!

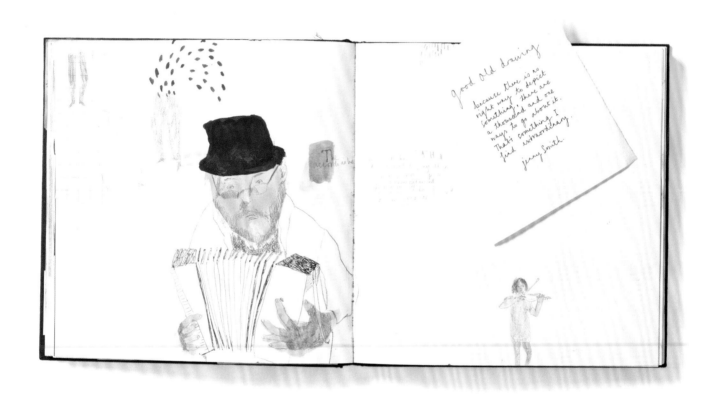

Good Old drawing

because there is no
right way to depict
something, there are
a thousand and one
ways to go about it.
That's something I
find extraordinary.

Jenny Smith.

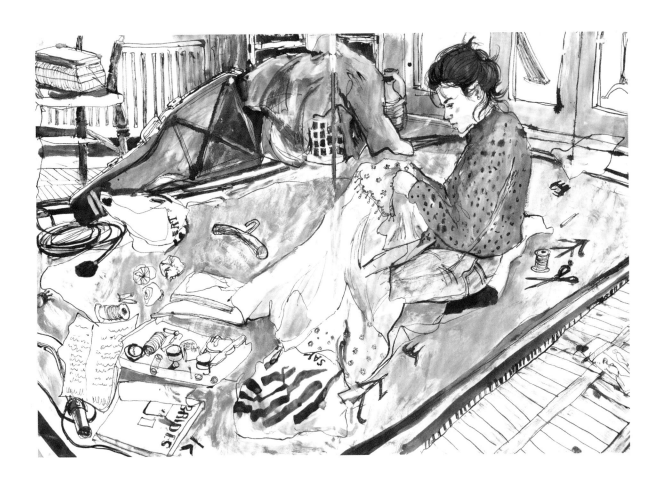

" *Good Old Drawing and why I love it: when the drawing is working fluently – the information being translated, weighted and fixed on the paper, that feeling is not unlike being in the throes of a romance.* "

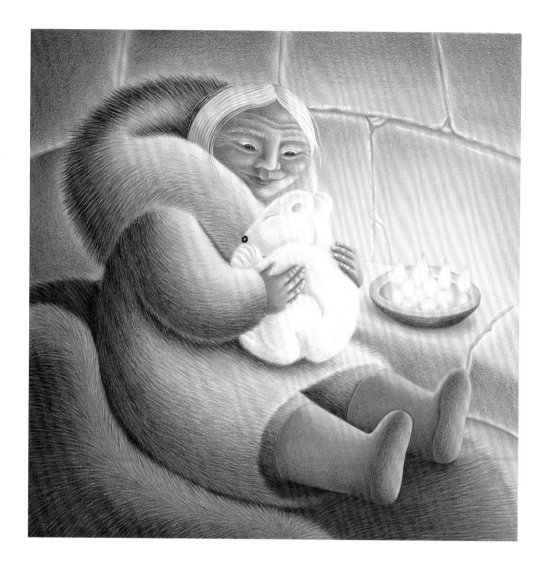

" *For me, the things I want to draw are in my head, and when I relax enough, thoughts, even unformed thoughts, come straight down my arm and through the pencil, with no blockages or uncertainties, out onto a bit of paper – often literally the back of an envelope behind my bed. I now try to have a book within reach to catch these idea drawings in. These to me are the best and most precious drawings, as they have an unrepeatable vitality. Drawing in pencil helps too; I know I can always rub it out, so it lets me take more risks.* "

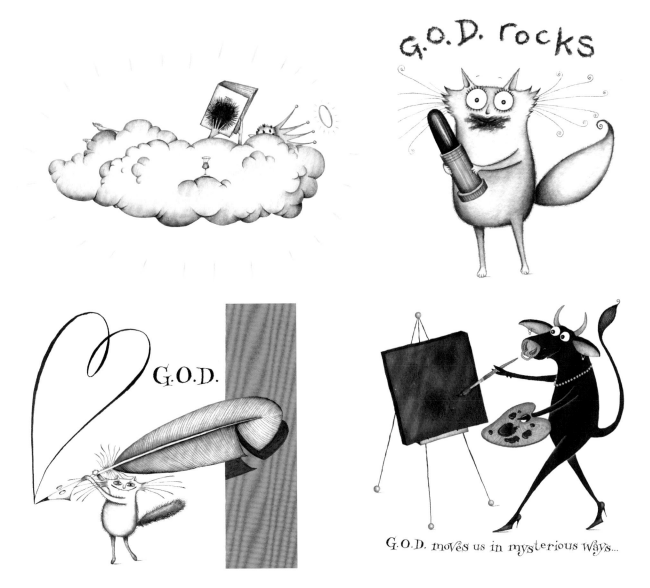

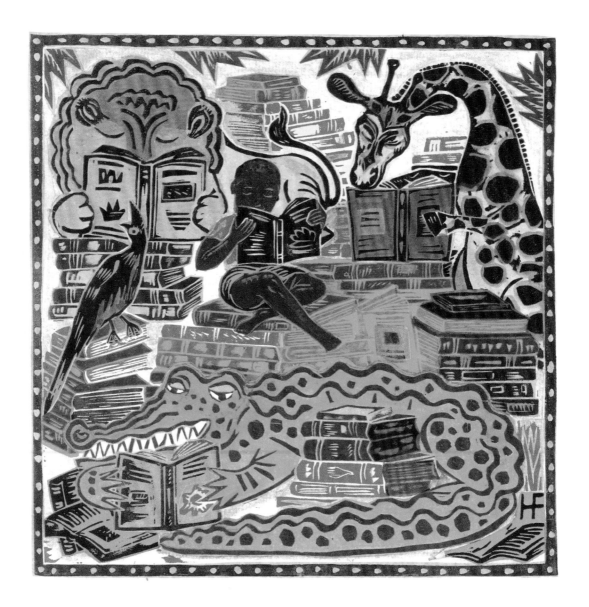

" *The reason why I believe in G.O.D. Well observed drawing is the backbone of all good work.*
Whatever the eventual creative style, whether it be minimal or abstract, paint or woodcut;
a good sense of proportion and balance in design are vital for a pleasing and original result.
These are achieved through the practice of Good Old Drawing! "

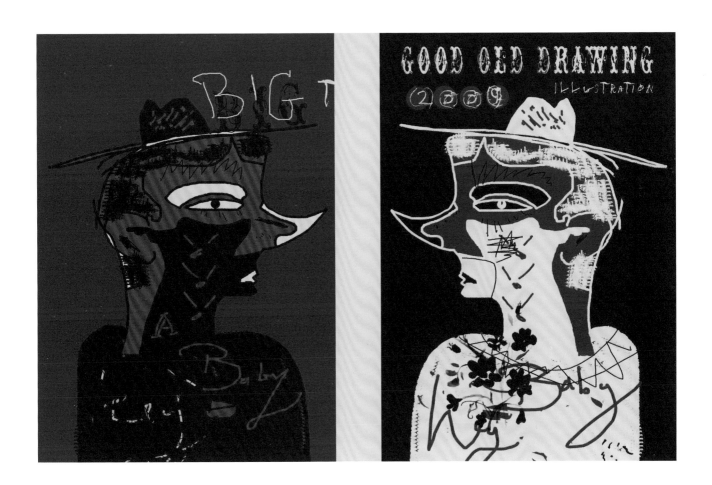

" *Good Old Drawing…a bit like a very good friend…making marks and playing with shapes…*
a way of putting down thoughts…ideas…being able to do magic…a way of showing off…
I'm aware one is only as good as the last one…some work some don't…
anyone can do it if they WANT to…it's simply what I do and enjoy most… "

*" We all 'draw' from life – it's just that some of us interpret 'drawing from life' as 'taking from life',
hence my abstracted images. Drawing to me is the most direct art form, a direct link to your inner soul.
G.O.D. – it does not have to be old but it does have to be good and drawing. "*

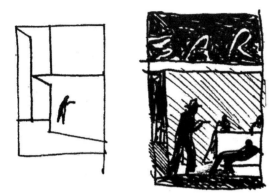

" *The process of original image development made extensive and intense use of compositional 'thumbnail' drawing, before extending into tonal experiments and resolution. These processes and developments sought to strip back the more visually complex imagery of film and photography in order to uncover a more rationalised yet narrative series of images. Through its continued simplification and clarity of communication, this work seeks to explore territory previously dominated by film stills, photography and abstract painting. What I mean to say is that it's not until the idea of a picture in my head touches down on paper that the dynamic possibilities start to open up and then I find it difficult to select a single resolution.* "

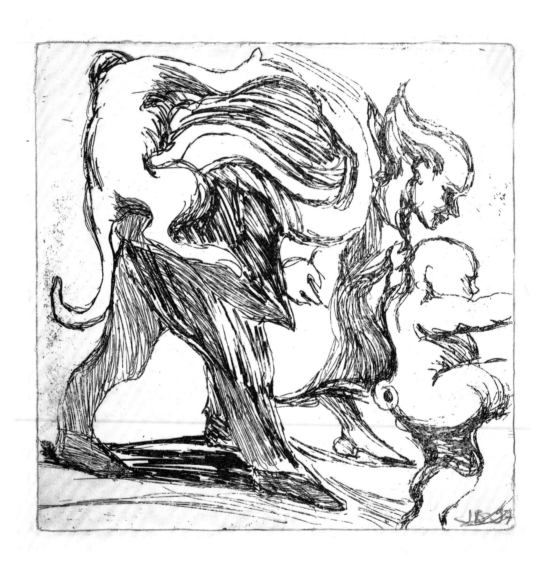

" I love drawing for the murmer of things you can't see. "

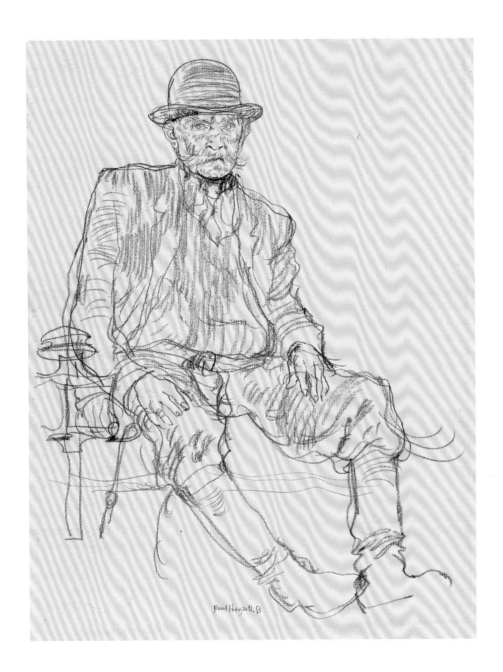

" *Surely, no pleasure can be greater than to practise the art of drawing. Even now,*
in my eightieth year, the magic of making drawings, of sending them to persons unknown and then
having them come back in the pages of books and magazines, in addition to the stimulus of exhibiting
the originals, has never failed to gratify. And, as my mother once said, "it beats working." "

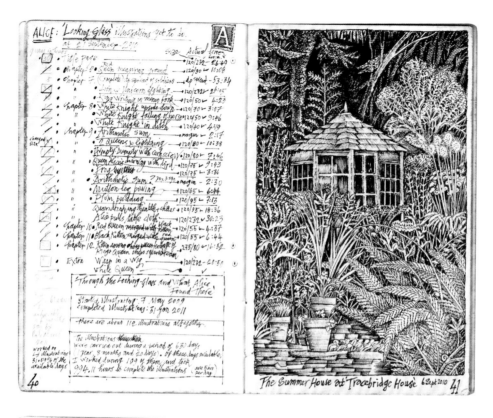

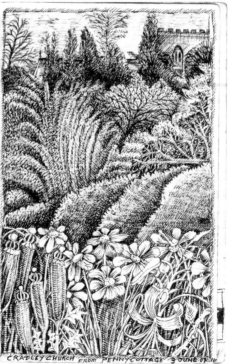

The Summer House at Tracebridge House 6 Sept 2010

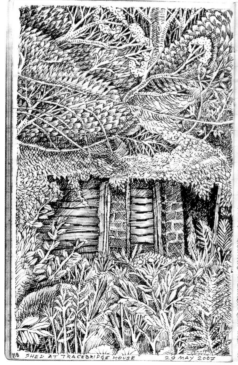

SHED AT TRACEBRIDGE HOUSE 29 MAY 2007

CRATLEY CHURCH FROM PENNY COTTAGE 3 JUNE 07

Why I believe in G.O.D.

I believe in good old drawing because it is one of the best ways I know of appreciating what I am looking at. Drawing helps me make sense of things. The concentration that takes place when you are doing a drawing from direct observation intensifies the experience and the wonder of vision. Things that you look at are far more surprising when you commit yourself to a drawing. I believe in Good Old Drawing because it allows me to interpret the observed world, as well as the imagined and the remembered. I believe in Good old Drawing because I love looking at other people's drawings. Drawings can make us stop to think, they may move us, and they may make us laugh. They can explain things like nothing else can. I love Good old Drawing because I wouldn't know what else to do without it. Drawings are wonderfully still, flat and silent — they don't rush about making a noise!

Drawing for me is trying to visualise and bring to life the ideas and range of interpretations that lurk like misty visions inside my head — the composing; the fumbling and stumbling; the sorting out of marks; the rubbing out; the hesitations; the adjustments; the decisions; the hopes and anticipation; the heart ache; the overcoming of weaknesses; the taking of risks; coping with and taking advantage of unexpected developments that may arise; gathering up strengths; getting the desired expression and mood; establishing the content; inventing new worlds and the whole process of reaching towards a visual conclusion. This is what appeals to me whilst drawing. I love the solitariness too — being on your own with eyes, head, heart and hand, something to draw with, something to draw on, and something to draw about. Good Old Drawing.

John Vernon Lord

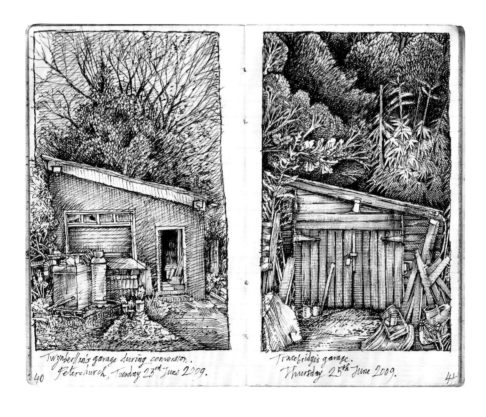

Twynberlin's garage during conversion. Peterchurch, Tuesday 23rd June 2009.

Tracebridge's garage. Thursday 25th June 2009.

40 41

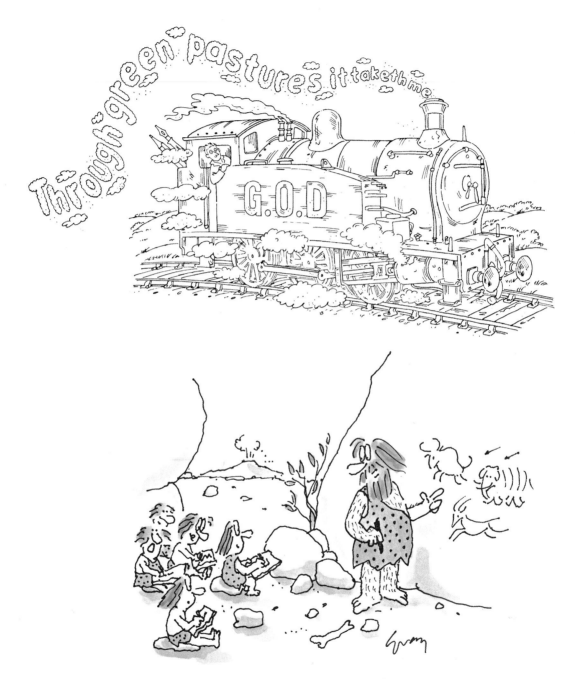

"For now we'll be concentrating on 'Good Old Drawing'. Later we'll progress to the modern stuff."

MY ONLY
TASK IS
TO FILL THE
PAGE

YOU HAVE NOT

BEEN GIVEN A TASK

IT SUMS UP MY ATTITUDE TOWARDS GOD
- DAVID SHRIGLEY

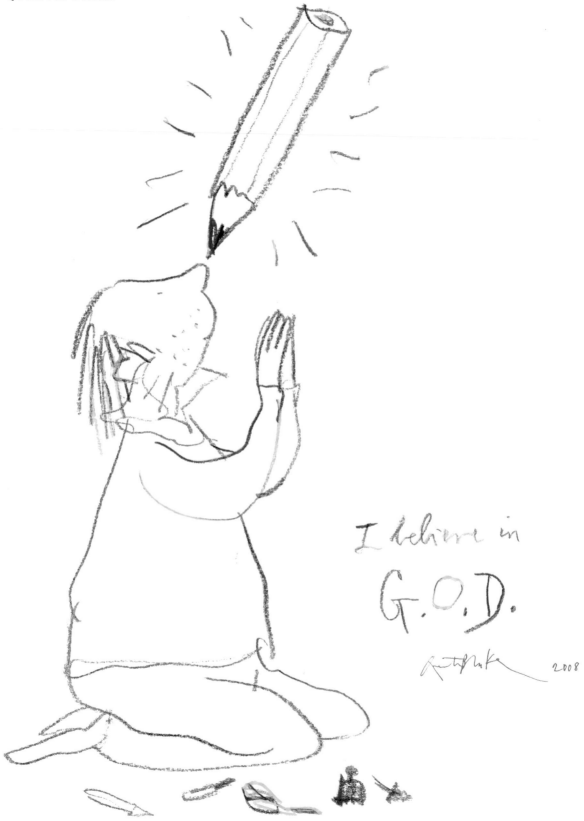

I believe in
G.O.D.

Special thanks to all the Disciples for believing in G.O.D.

Without their generous contributions in words and drawings
this book would not have been possible.

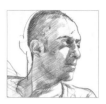

JULIAN ALLEN (1942 - 1998) was born and raised in Cambridge, England where he went to art school. Julian lived most of his adult life in the United States. His distinguished career as an illustrator and educator kept him busy creating images for most national and international magazines and sharing his knowledge with thousands of students for over twenty years. He has been a recipient of numerous awards. **P. 32**

ROGER ALSOP was born in Skipton in 1946 and once spoke with a Yorkshire accent. At the age of four he moved to Wisbech and changed to Fennish. After school, for social climbing reasons, he upgraded to semi-posh RP. He loves 1950's lorries and sometimes uses the term 'hermeneutic'. **P. 87**

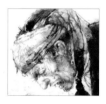

VICTOR AMBRUS ARCA, RE, FRSA was born in 1935 in Budapest, Hungary. He trained at the Academy of Fine Art, Budapest for three years but fled to England after the Hungarian Uprising of 1956 against the Soviet Union. He completed his studies at the Royal College of Art, London and has since become a freelance illustrator, contributing to almost 300 books and winning numerous awards, including the Greenaway Medal for Illustration in 1966 and 1975. He is also the resident illustrator for Time Team on Channel 4. **P. 22-23**

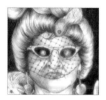

CANDY AMSDEN, following expulsion from school, trained at Cambridge School of Art and the Royal College of Art. Limited talent but hard graft and years spent drawing led to work as a 'radical' illustrator. She lives in Tottenham, London, which sources her ideas. Her current work includes an insect book for children. **P. 27**

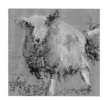

DIANA MAXWELL ARMFIELD RA, RWS was born in 1920 in Ringwood, England. She studied at Bournemouth, Slade and Central Schools of Art and taught at the Byam Shaw. She has been an artist in residence in Perth, Australia and Jackson, Wyoming, USA. Her work has been exhibited at many galleries, including Browse & Darby, The Royal Academy, Albany Gallery, Cardiff, Royal Watercolour Society, Curwen and New Academy and the V&A. See *The Art of Diana Armfield* published by Halsby. She currently works in London and Wales. **P. 93**

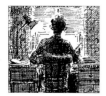

PETER BAILEY has worked as an illustrator since 1968, mostly in the field of Children's Books but also in Advertising and Design. He has also illustrated a number of books for The Folio Society, including a three volume set of Philip Pullman's *His Dark Materials* trilogy. **P. 51**

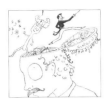

JACK BEDEMAN lives in a world of whimsy, well his head does anyhow. The rest of him does as it's told and calmly keeps up. Born in the back row of a lecture theatre his illustrations have grown to be used in animations from Australia, to the playhouses of London. **P. 83**

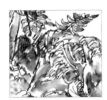

RICHARD BELL trained as a natural history illustrator at the Royal College of Art in the 1970's and has worked mainly as a book illustrator and writer. Based in West Yorkshire, he self-publishes walks booklets, trail guides and facsimile sketchbooks focussing on the local landscape, its geology, history and wildlife. **P. 81**

STEVE BELL was born in 1951 in Walthamstow, London. In 1968 he moved to North Yorkshire with his family, where he trained as an artist at the University of Teesside and as an artist and filmmaker at Leeds University. He then trained as a teacher at University of Exeter and went on to teach in Birmingham before becoming a freelance cartoonist in 1977. His comic strips and drawings have since appeared in several publications including his *Maggie's Farm* comic strip which appeared in Time Out and City Limits, *The Lord God Almighty* which appeared in The Leveller and *If...* which has appeared in The Guardian every day since 1981. He claims to have been the first to spot Margaret Thatcher's mad left eye and also Tony Blair's. In 2003 he was listed as one of the 50 funniest acts in British comedy by The Observer and was voted the Best Cartoonist in 2004 by the Press Gazette. **P. 8**

JOHN BENDALL-BRUNELLO has nearly 30 years experience as a children's book illustrator, working with the top publishers in both the UK and the USA with co-editions in nearly every country in the world. He has illustrated books written by some of the most prestigious authors of children's books today including Dick King Smith (*Babe*) Martin Waddell (*Can't You Sleep Little Bear, Farmer Duck*), Sally Grindley & Malachy Doyle, amongst many others. His own titles include *Dinosnore!* published in 2009 by Andersen Press and *The Seven and One Half Labors of Hercules* published in 1991 by Dutton Books. **P. 48**

QUENTIN BLAKE CBE, FCSD, RDI, born in 1932, has illustrated over 300 books, including *The BFG*, *The Witches*, *Matilda*, *Revolting Rhymes*, *Esio Trot* and several other titles by Roald Dahl. He has also written and illustrated his own books, including *Angelo*, which later became the basis for a children's opera. He is the recipient of numerous awards including the Hans Christian Anderson Award for Illustration. A teacher for over twenty years at the Royal College of Art, he was head of the Illustration department there from 1978-86. In 1999 he was appointed the first ever Children's Laureate. **P. 122**

JOHN BOLAM (1922 – 2009) was born in Amersham. He studied furniture design at High Wycombe and painting at Hornsey. Following time with the Friends' Ambulance Unit he worked in Cambridge and was head of CCAT School of Art until retirement in 1983. His love of the English landscape was reflected in his painting and drawing. **P. 89**

JUDY BOREHAM was born in Germany in 1960. In 1995 she received her BA Hons in Illustration A.R.U. Her work was exhibited in the European Illustration Show Hull in 1997. She has received numerous awards, including the Folio Society Illustration Award, Royal College of Art London 1997 Joint 2nd prize and Icon Book Award 1997. She received her Masters from the Royal College of Art in 1997. Her set design for *Yamanba* by Jia-Yu Dance Company 2006 performed at The Junction Cambridge, New Wolsey Theatre Ipswich and The Place London. **P. 116**

GLYNN BOYD HARTE (1948-2003) Dip. AD. MA was born in Rochdale. He was educated at St. Martins and the RCA where he studied illustration. Glynn mixed the careers of painter, printer, designer, writer and composer, showing in several London galleries and producing lithographs at the Curwen Press. He always stressed the underlying importance of drawing. **P. 31**

PETER BROOKES was born in Liverpool in 1943. Son of an RAF Squadron Leader he joined the RAF to train as a pilot but left to study at Manchester School of Art and the Central School of Art & Design. Winner of Cartoonist of the Year awards 2011, 2010, 2007, 2005 and 2002. He is leader-page cartoonist at The Times. His 'Pope Benedict the XVI' elicited a rebuke from Cardinal Cormac Murphy O'Connor. **P. 39**

CHRIS BURKE, 25 years ago gave up a cushy advertising job to become an inky fingered doodler. His so-called illustrations and caricatures have blighted the pages of almost every major British publication, eighty odd bookshops, underground stations, billboards, theatres, children's books, stamps and the loos of the famous. **P. 106**

JIM BUTLER was born in Dublin and runs the BA Illustration & Animation at Cambridge School of Art. His practice is centred around artist's books, printmaking and drawing. Exhibiting internationally, his works are in several public and private collections including Tate Britain, The Art Institute of Chicago and The Hague's Meermanno Museum, while commercial clients include Adidas and Siemens. **P. 44**

CHLÖE CHEESE was born in 1952 and lived in the village of Gt Bardfield, Essex. She attended Cambridge Art School from the age of sixteen and then went on to London and the Royal College of Art. Chloe has worked as a freelance illustrator and exhibits lithographs, paintings etc. Her work evolves from her observational drawings. **P. 47**

ANN CHRISTOPHER RA studied sculpture at Harrow School of Art and The West of England College of Art from 1965-69. She was elected to the Royal Academy in 1980. She has held numerous solo exhibitions of her non-figurative sculpture and drawing and has had many works commissioned for both public and private spaces in UK, Europe and USA. **P. 114**

JOHN CLARK BA Oxon 1986 is an artist and rugby player. As a sculptor between the years 1986 and 1996 he co-founded the Glasgow Sculpture Studios, lectured at Greys School of Art and was Visual Arts co-ordinator for Tramway. Between 1996 and 2010 he became a lead artist and art director in the gaming industry. He left Sony in 2010 to concentrate on painting. **P. 25**

SUE COE, born in England, attended the Royal College of Art in London, then settled in New York. As an animal advocate and artist, Sue lectures, gives workshops, and has displayed her work in exhibitions globally. She has written many articles and eight books, including *Dead Meat*, winner of the 1991 Genesis Award and *Sheep of Fools*, winner of the 2005 Peta non-fiction book of the year. She has worked as an editorial artist for The New York Times, The Progressive and many other newspapers and magazines. The Culture and Animals Foundation awarded Sue the 1994 Outstanding National Activist Award. Her paintings are now housed by art museums, institutes, libraries, foundations and universities internationally, including the Museum of Modern Art and the Metropolitan Museum of Art in New York and the Smithsonian, Washington DC. **P. 70**

CHRISTOPHER CORR was born in London. He studied at the Royal College of Art where he was awarded the RCA drawing prize and a Leverhulme scholarship to travel in the USA. Travel provides much inspiration for his work. He has worked as artist for Quantas, Windstar Cruises, made stamps for Royal Mail and the United Nations and posters for Transport for London, Ikea, Habitat and the Body Shop. **P. 49**

PAUL COX, freelance illustrator, has worked for numerous publications both here and in the USA since leaving the RCA in 1982. Most of his published work is editorial drawing for newspapers, magazines and many illustrated books. His illustrations and topographical watercolours are regularly exhibited at the Chris Beetles Gallery with a large retrospective planned for 2013. **P. 58**

MARGOT COX, a graduate of St. Martins has had an extensive career as an art director in publishing. Now, as an artist preoccupied with movement, she explores the formal language of figurative drawing and painting. Incorporating volume, light and space Margot creates an emotional landscape bridging the gap between representation and abstraction. **P. 24**

MIKE CRAIG, after graduating from Cambridge Art School in 1973, was a freelance artist perfecting a style of pen and ink drawing reminiscent of the engraving traditions from an earlier and less frantic age; but there is no money in that. He has become one of Ireland's foremost graphic artists and the fine detail of his work inspired many stamps for the Irish Post Office. He is responsible for the highly acclaimed *Mausolea Hibernica* and *Fish Out of Water*, and now writes poetry for solace. He likes fishing, rock-pooling and animals (in small amounts). He would like Cambridge to be moved to Ireland, or vice-versa. **P. 82**

PER OSCAR GUSTAV DAHLBERG grew up among the lakes and forests of Sweden where his artistic life was encouraged. Per then studied art at CCAT, Cambridge and at the Royal College of Art, London where he received his MA and PhD. Per's illustrations and animated diaporamas have been shown worldwide and have won many international prizes. Per lives in Sopot and Paris. **P. 75**

BILL DARRELL (1913–1987) taught himself to draw using Vernon Blake's *The Art and Craft of Drawing*. Post-war he studied at the Slade, then lectured at the Cambridge School of Art from 1948 for thirty years, while evolving his drawing and painting styles. He regularly exhibited with the Cambridge Society of Painters and Sculptors. **P. 54**

DAVID DOWNES was born in Sutton Coldfield in 1971. He gained an MA at the Royal College of Art in communication design in 1996. In 1999 he set out to record the BBC's important series on architecture at the turn of the century. In 2000 he became artist in-residence to BBC Heritage. David is the subject of a book written by Shelia Paine, *Artists Emerging*. David lives and works in London. **P. 72**

CHRIS DRAPER was born in 1965 in Birmingham. He studied at Central St. Martins and the Royal College of Art. He is an illustrator and educator. Despite using collage and photography in his professional practice, almost all his pieces start out as drawings. He is currently running the Illustration BA at Cambridge School of Art and remains a passionate advocate of drawing in all its forms. **P. 53**

DAVID DRIVER was born in Cambridge in 1942. He studied at Cambridge School of Art from 1959 to 1963 and was made an Honorary Doctor of Letters in 2001 by Anglia Ruskin University. He has illustrated for the Illustrator, Town, Queen, Vogue and Penguin Books. He was Head of Design at The Times from 1981 to 2008 and received awards for his work there in 1989 and 1994. He has designed two collections of stamps for the Royal Mail, on the themes of Christmas (1991) and the Queen's Golden Wedding Anniversary (1997). **P. 90**

LEO DUFF MA, RCA, is Academic Director of Overseas Development of the Faculty of Art, Design & Architecture at Kingston University London. She continues to explore drawing through subjects stemming from her involvement with the built environment and heritage. This ranges from the new 'under construction' China to archaeology at Stonehenge. Practicising what she teaches she uses her research from drawing residencies for workshops and masterclasses in many international locations. **P. 37**

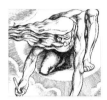

DAVID ECCLES was born in Ireland in 1947 and studied graphics at the Central School, London. He worked as book designer and latterly as illustrator for publishers such as Thames and Hudson, The Folio Society and John Murray. Married, he lives in Balham with an Albion press and many bicycles. **P. 74**

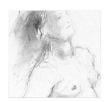

EITHNE FISHER was born in 1954 and studied in Swansea and at Anglia Ruskin University. She lives in Cambridge where she is a painter, drawer and teacher. A member of the Posers life-drawing group and the Cambridge Drawing Society, she also participates in Cambridge Open Studios, gardens and writes poetry. **P. 104**

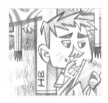

JONATHAN EDWARDS is an illustrator, comic artist and character designer. His work has appeared in magazines, books, comics, shop windows and on the covers of records. He is a regular Guardian contributor and has illustrated the Guardian Guide's Hard Sell column since 2002. He is never far from a pencil. **P. 62**

PETER FLUCK, born in 1941 in Cambridge, is well known for co-founding the legendary Spitting Image satirical television puppet series. One of the most successful programmes of its time, it was broadcast from 1984-96. He now works making mobiles and ceramics. He and his wife, the painter Anne-Cecile de Bruyne, live on a clifftop in a remote part of Cornwall. **P. 65**

HANNAH FIRMIN trained at Chelsea and the RCA where the love and importance of drawing was instilled in her. Since 1981 she has worked as a freelance illustrator and printmaker, combining her use of the relief print with paint and collage, for use on book jackets, in advertising and book illustrations, as well as exhibiting widely. **P. 112**

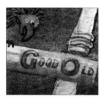

MICHAEL FOREMAN RDI, has written and illustrated more than fifty of his own books, in addition to illustrating more than two hundred books by other writers, ranging from Shakespeare and Dickens to J G Ballard and Michael Morpurgo. Twice winner of the Kate Greenaway Award, he has had solo exhibitions of his work in London, Paris, New York, Japan and Santiago, Chile. He is an Honorary Fellow of the Royal College of Art. **P. 59**

SUSIE FOSTER MA, RCA, is an artist and designer. She studied textile design at Chelsea College of Art and Design (2003-2006) and the Royal College of Art (2009-2010). Drawing has always been a fundamental part of her work and whilst at the RCA she won the John Norris Wood prize for drawing natural forms two years running. **P. 56**

ANNE GRAHAM is a resident of Banjo Town, Pennsylvania, where she specialises in portraiture and figurative work. She returned to the Philadelphia area after 40 years, having trained first at Brooklyn's Pratt Institute, then specialist art schools in Cambridge and London, England. Her portraits grace the walls of many of the finest homes and institutions on both sides of the Atlantic. **P. 43**

GEOFF GRANDFIELD was born in Bristol, England, in 1961. He currently lives and works in London and is Course Director of BA Illustration and Animation at Kingston University. His work shows an obsession with the imagery of 'film noir' that surfaces in a diverse range of commissions for newspaper, magazine and book illustrations. **P. 115**

HARRY GRAY is the son of the Queen's Mounted Drummer and show jumping instructor. He was conceived at Horse of the Year Show, 1962. He found sanctuary in a grammar school art room and went on to study sculpture at Sunderland Art School. From there he went on to receive several big commissions, including The Battle of Britain Monument, Dover, which was opened by HRH, The Queen Mother. His less famous commissions include a Panda in stone, for a Glaswegian lorry driver. He works in Cambridge. **P. 76**

BRIAN GRIMWOOD was quoted by Steve Heller in PRINT magazine as having changed the look of British Illustration. He has worked for such diverse clients as The Beatles, ASDA, The Proms, The New York Times, Sony and most famously did the Johnnie Walker logo. He has lectured in China, Australia, America, Singapore and Norway. He is a patron and founding member of The Association of Illustrators and owns England's foremost illustration agency: The CIA. **P. 113**

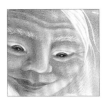

AMANDA HALL was born in 1956 in Linton, Cambridgeshire. She trained in illustration at the Cambridge School of Art and has illustrated 50 books for children. She has exhibited at the Chris Beetles Gallery, London. Her father was John Hall. **P. 110**

JOHN HALL (1921-2006) was born in Cottingham, Hull. His training in art was interrupted by war service in Ceylon (now Sri Lanka), but he subsequently completed it at Hull Art School. John taught at Cambridge School of Art from the 1950s to the 1980s. He also designed sets and costumes for productions at the Mumford Theatre and other theatres in Cambridge. **P. 92**

JONNY HANNAH studied at The Cowdenbeath College, Liverpool Art School & the Royal College of Art. He has worked as a freelance illustrator for a long time. His many clients include The New York Times and The St. Kilda Courier. He loves to draw and listen to Slim Gaillard. **P. 67**

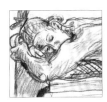

JON HARRIS was born in Stoke-on-Trent in 1943. He wasn't meant for an artist; always doodled, though, then sketched. After university, he never left Cambridge, finding locally all he wanted to paint. Self-taught until 1995 he took students out location-drawing, though still, seldom without a venerable Rapidograph. A retrospective of his work, 'Painter about Cambridge', was exhibited at the Fitzwilliam Museum/Scroope Terrace in 1997. **P. 107**

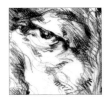

TONY HEALY was born in Wales and studied at Swansea School of Art. He moved to London in 1982 and began work as a freelance illustrator, initially for BBC Current Affairs. Since then he has worked extensively in the media and publishing and currently supplies weekly profile illustrations for the Daily Telegraph and Financial Times newspapers. **P. 60**

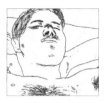

DAVID HOCKNEY CH, RA, born 1937, is a painter, draughtsman, printmaker, set designer and photographer based in Bridlington, Yorkshire. When studying at the Royal College of Art in London he was included in an exhibition of Young Contemporaries, and went on to become one of the most influential artists of his generation. His most notable works include *A Bigger Splash* and *We Two Boys Together Clinging*. He has recently been one of the first artists to embrace the iPad as a drawing tool. **P. 55**

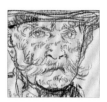

PAUL HOGARTH (1917-2001), OBE, RA, Dr., RCA, RDI, was one of the most celebrated illustrators and graphic artists of his time. As a young student he attended St. Martins before joining the International Brigade in the Spanish Civil War. In the body of work that followed, topography, illustration and reportage are uniquely combined and have achieved the status of fine art, a fact reflected in his membership of the Royal Academy. His deep and interrelated passions for travel and literature also served to focus and direct the course of his career: from his working trips to China, the USSR and the Soviet satellite states, to the time he spent living in the United States, his drawings provide startling insights into six decades of world history, whilst his collaborations with celebrated writers such as Doris Lessing, Robert Graves, Lawrence Durrell and, perhaps most notably, Graham Greene, made his work familiar to millions across the world. **P. 117**

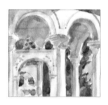

JAMES HORTON has exhibited widely in Britain, including the Royal Academy, Agnews and also abroad, particularly in India. He is a successful portrait painter and has published nine books on painting and drawing. Currently he is president of the Royal Society of British Artists. **P. 103**

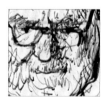

KEN HOWARD OBE, RA, born 1932, studied at the Hornsey School of Art, and following a period of National Service, he continued his studies at the Royal College of Art in London. The recipient of numerous awards, his work can be found in many public collections, including The Imperial War Museum and the Guildhall Art Gallery. *Light and Dark: The Autobiography of Ken Howard* was published in 2010. **P. 29**

DAVID HUGHES was born in Twickenham in 1952. He attended Twickenham College of Technology from 1968-72. He had a succession of jobs between 1972 and 1980, including a stint as a postman; one of the addresses he delivered letters to belonged to the illustrator Eric Fraser. He was a Graphic Designer for Granada Television from 1980-85. His illustration work got noticed for The Observer Sunday Magazine in the 'A Dr. Writes' page (1990-2). Subsequently his work has appeared in The New Yorker, Esquire (USA), GQ (USA), Entertainment Weekly, The Washington Post, Punch and The Guardian. Hughes has won various illustration awards and literary prizes for his books including *Walking The Dog* (2009), *Silent Night* (2000), *Shakespeare's Othello* (1997) and *Bully* (1990). **P. 34-35**

JANE HUMAN is a London based painter and printmaker whose primary focus is the exploration of a sense of place through representation of landscape. Her work has been shown in numerous juried exhibitions including the RA Summer Exhibition, the Royal Society of British Artists, 'Originals' national Print Open, Laing Landscape Open and many other galleries in London and the British Isles in both solo and mixed shows. She is also a regularly exhibiting member of the Printmakers Council. Jane's background includes a highly regarded illustration career, working for international clients and brands. She continues to be involved in education as an occasional lecturer at Cambridge School of Art, Anglia Ruskin University and as an External Examiner elsewhere. **P. 64**

DAVID HUMPHRIES failed O-level art. He has illustrated national advertising campaigns and draws pictures for newspapers and magazines, both in the UK and abroad. He lives in London with his wife, two children and seven bikes. **P. 63**

BENOIT JACQUES was born in Brussels in 1958. He studied drawing at Brussel's Fine Art Academy (1974-8) and graphic design at La Cambre Art College (1978-9). He then moved to London and went on to publish drawings in the international press. In 1989 he published his own book of drawings. In 1991 he moved to France, where he lives and works in a small village, south of Paris. **P. 94**

GRAY JOLLIFFE, an ex-advertising creative director, started cartooning as a baby on the walls of his parent's house and has since appeared in many magazines, newspapers and TV commercials. His cartoon strip *Chloe and Co* has been running in the Daily Mail every day for fifteen years and in 2010 he won Strip Cartoonist of the Year. He has also written and illustrated many books including the best-selling *Wicked Willie*. Wicked Willie came to Gray in the bath, the traditional place for getting good ideas and within a year they had a world-wide hit in their pants. Gray loves Good Old Drawing and loves to keep busy. **P. 120**

PATRICIA JORDAN studied fine art printmaking and photo media at Central St Martins and Illustration at the Royal College of Art. Her charcoal drawings are intimate studies of dead birds, birds nests and endangered species. She has appeared in various group shows including Flowers East, London. **P. 57**

COLIN KING, after attending Colchester School of Art, gained an MA degree in illustration at the Royal College of Art. He then worked as a freelance illustrator, whilst teaching part time at Harrow, Cambridge and Wimbledon Art Schools. He has been illustrating children's books for Usborne Publishing for over 35 years. **P. 120**

ROGER LAW used to be famous. In the 1980's and 90's he was the artist and energy behind the satirical television programme Spitting Image in the UK. The success of the puppet show, which pilloried the rich and famous, made him rich and famous, so he quietly deported himself to Australia to concentrate what was left of his talent in that sunburnt country. He is based in Sydney and makes ceramics in Jingdezhen, China's 'Porcelain City'. Some of this work was exhibited at the V&A in 2011. **P. 68-69**

JOHN LAWRENCE is a book illustrator and wood engraver for children's books, trade, private press books and ephemeral graphic design. He has illustrated over 200 books. He has been a Visiting Professor at London University of the Arts and at Cambridge Art School (Anglia Ruskin University). He was Master of the Art Workers Guild in 1990 and is a member of the Royal Society of Painter Printmakers and The Wood Engraving Society. His work is represented in the Ashmolean, the V&A and many collections in the USA. He has an archive in the All Saints Library at Manchester Metropolitan University and Seven Stories in Gateshead. **P. 66**

RENOS LOIZOU comes from a small village, famous for its figs, in the hot, flat centre of Cyprus. After studying at Cambridge College of Art, his first solo exhibition was at Fitzwilliam College in 1969. His work, mostly oil on paper and often inspired by a particular landscape he once saw at Mojacar in Andalusia, is now featured in collections worldwide. He lives in Soham, in the Fens, with his Jack Russell, Igor. **P. 46**

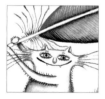

CLARE MACKIE, having been surrounded by animals and insects, due to her farming background in Scotland, has incorporated these creatures into her illustrations with the small edition of handbags and stilettos. Clients as varied as The New Yorker, IBM, Country Life, Fairhills, Harvey Nichols, Chanel have all been seduced by G.O.D.'s creatures. **P. 111**

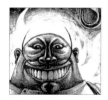

ROBERT MASON has worked as an illustrator, writer and lecturer since leaving the Royal College of Art in 1976. Currently writing takes precedence - Robert has completed his first crime novel and doesn't miss the drawing that has always formed the core of his work. Time will tell whether this unnatural situation becomes permanent. **P. 26**

LEONARD MCCOMB RA was born in 1930. He studied at Manchester College of Art and Painting & Sculpture at the Slade School. He has taught at various schools and between 1995 and 1998 was Keeper of the Royal Academy Schools. He has exhibited in America, China, Venice Biennale and Germany. His works can be viewed in the Tate, V&A, National Gallery, British Museum and in public and private collections. In 2010 he designed two mosaics for Westminster Cathedral. **P. 91**

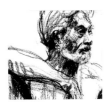

PETER MENNIM, after two years on a degree course in Fine Art at Reading University, and a decade working as the court artist for a crazy guru in India, he returned to UK and worked as a jobbing illustrator producing many movie posters, book jackets, record covers etc. Later he earned his living as a portrait artist. He has now shifted back to a more expressive 'fine art' approach to painting. **P. 77**

FRANCIS MOSLEY was born in Nottingham in 1957. He attended art college at Brighton from 1979-82. He then moved to Kathmandu and worked for VSO and illustrated Sherlock Holmes for Folio. He then moved to Shropshire, kept chickens and did the complete works of Joseph Conrad in linocuts. He then moved to Rome, then back to London and now he lives in Bath and is doing more painting. **P. 101**

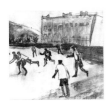

SAM MOTHERWELL was born in 1941 in Ballywalter, Northern Ireland. He has lived in Cambridge since 1968, pursuing a career in research chemistry. A long-time member of the Cambridge Drawing Society, he works figuratively, in charcoal, pen and ink and collage, and published a book of 114 linocuts of Mill Road. **P. 86**

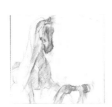

ROSEMARY MYERS studied printmaking at Harrogate Art School, then illustration at Cambridge School of Art. She worked freelance for various UK publications but became a printmaker. She took a Masters in Fine Art Printmaking at Anglia Ruskin University graduating in 2009. She continues to draw every day; drawing gives amazing knowledge. **P. 100**

THOMAS NEWBOLT is a painter and printmaker who teaches life drawing at the Prince's Drawing School in London. He has studied and travelled in Italy and the USA and now works in a studio in East Anglia. He is married with two sons in their thirties. He draws every day. **P. 36**

JOHN NORRIS-WOOD, Professor: RCA and Southampton University, artist, lecturer, naturalist and passionate conservationist. He studied at Goldsmiths and the Royal College of Art, was a tutor at Cambridge School of Art (1959-70) and founded the Natural History Illustration and Ecology Studies, RCA. His exhibitions include: Royal Academy, Natural History Museums London and Venezuela, The Fry Gallery, Redfern and Museum of Zoology, Cambridge University. His ecological expeditions have included The Galapagos Islands, Belize, Zaire, Yucatan, Mexico and Okefenokee Swamp, USA. **P. 78-79**

CHRIS ORR was born in London in 1943 and graduated from the Royal College of Art in 1967. He was elected as a Royal Academician in 1995 and was Professor of Printmaking at the Royal College of Art 1998–2008. His productions include prints, paintings and books. He lives and works in Battersea, London. **P. 30**

CAROL PEACE studied sculpture at Winchester School of Art and drawing at The Prince's Drawing School. She has obtained numerous commissions both public and private with solo shows in London, Athens, Zurich, France, Spain and Holland. In 2007 she co-founded the Bristol Drawing School and is currently the artistic director there. **P. 28**

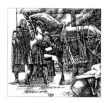

ROMAN PISAREV was born in Leningrad in 1963. He studied at the St. Petersberg Stieglitz State Artistic and Industrial Academies. A book illustrator, portrait painter and medal-maker he has illustrated many books for the Folio Society and Azbooka Atticus, Moscow. He won the Waterstones Ilustrator of the Year Award in 1999 and is an Associate Professor at the St. Petersburg Institute of Arts & Crafts. **P. 50**

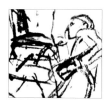

SAM RABIN (1903-1991) was an artist, sculptor, teacher, opera singer and professional wrestler. At the age of eleven he won a scholarship to Manchester Art School. He studied at the Slade from 1921-24 and in 1928 he was a wrestling bronze medallist at the Olympic Games. From 1945-65 he was a drawing teacher at Goldsmiths and Bournemouth Colleges of Art. There was a retrospective of his work at the Dulwich Picture Gallery from 1985-86. **P. 61**

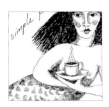

JANE RAY is an illustrator and author of childrens books. She was born in London and studied art at Middlesex University. Since leaving art school she has illustrated around 40 books, working with authors such as Carol Ann Duffy, Michael Rosen and Jeanette Winterson. Increasingly often though, she writes her own stories. She is also known for her greetings cards, posters and book jacket designs. **P. 98**

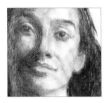

JOHN RICHTER was born in 1940. He attended Cambridge and Chelsea Art Schools and studied jewellery design at Sir John Cass College. He worked in America as a jewellery-designer in Boston and New York and then returned to England to paint pictures from his harbour studio in Wells-next-the-Sea. He has lived many lives and kept sketchbooks as he went. He now lives in Brixton, London. **P. 96-97**

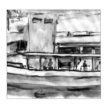

LOUISE RILEY-SMITH'S commissioned portraits hang in university colleges, schools and private homes. Her exhibitions include: The Royal Society of Portrait Painters, The Garrick/Milne Prize for a Theatrical Portrait (shortlist), The Discerning Eye, The Kettles Yard Open Exhibition, The Cambridge Drawing Society. She has also had several solo exhibitions which include Cambridge, Frost & Reed, St. James'. **P. 42**

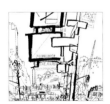

LUCINDA ROGERS is a reportage artist who has gained a wide array of clients in the publishing and design world as well as working on her own drawing projects. She specialises in depicting the lesser known parts of cities, particularly in urban East London where she lives. **P. 45**

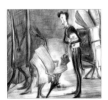

PORTIA ROSENBERG is an illustrator who works mainly in pencil and who is especially interested in character and narrative. She studied Illustration at Anglia Polytechnic University. She has illustrated two books: *Jonathan Strange and Mr Norrell* by Susanna Clarke, published by Bloomsbury, and *The Black Tulip* by Alexandre Dumas, for The Folio Society. She lives in a community outside Cambridge, is Jewish and loves soup. **P. 73**

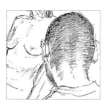

MARTIN SALISBURY studied illustration at Maidstone College of Art in the 1970's and went on to work for many years as a book illustrator and painter. He lectures at Cambridge School of Art (now part of Anglia Ruskin University) where he is Professor of Illustration and runs the MA in Children's Book Illustration. P. 105

BILL SANDERSON left Bristol Polytechnic with a DipAD in Graphic Design/ Illustration and was given his first work by Charlie Riddell at New Society in the early 1970's, and was then employed by many other designers in editorial, advertising and publishing. He is represented by Phosphor Art in England and Richard Solomon in the USA. P. 80

GERALD SCARFE CBE, RDI, born in 1936, was editorial cartoonist for The Sunday Times and is a regular contributor to The New Yorker. He has worked collaboratively across theatre, television, film and music, most notably on the Pink Floyd album, tour and accompanying feature length film *The Wall*. His caricatures of Tommy Cooper, Eric Morecambe, Joyce Grenfell, Les Dawson and Peter Cook featured on a set of five British postage stamps commemorating British comedians that were issued in 1998. He was awarded Cartoonist of the Year at the British Press Awards in 2006. P. 38

RICHARD SEYMOUR is a Drawist. He couldn't read until he was 9 years old, but he could draw a correctly-proportioned fire engine, in perspective, when he was 4. This probably means there's something wrong with him. He studied Illustration and Graphics at the Central School and then Graphics and Three-dimensional design at the RCA, where he's now a Senior Fellow (along with Ridley Scott....another drawist). He draws all day for a living as a designer, and when he goes on holiday he draws some more. He believes that drawing doesn't happen on the page, it happens in your head. He's from Scarborough in Yorkshire (which probably means there's something wrong with him). Where he lives now is none of your damn business. P. 17

RONALD SEARLE CBE, RDI (1920-2011) was forced to abandon his studies at Cambridge Art School in 1939 to enlist in the Royal Engineers. He is the creator of the St. Trinian's School and the co-creator of the Molesworth series. Searle did a considerable amount of designing for the cinema and in 1965, he completed the opening, intermission and closing credits for the popular comedy *Those Magnificent Men in Their Flying Machines* and in 1975, the full-length feature *Dick Deadeye*. He was awarded the *Légion d'honneur* in 2009 and has received the German Order of Merit. **P. 20-21**

RODNEY SHACKELL was born in 1942. He was a student at Cambridge School of Art (1957-62). He has since worked as a free-lance illustrator for many book publishers, magazines, advertising agencies and has produced many designs for Halcyon Days Enamels. Home is an ancient thatched cottage in Suffolk. **P. 99**

DAVID SHRIGLEY was born in Macclesfield in 1968. He has exhibited his drawings, photographs and sculptures in galleries and museums worldwide. He is the author of many books of drawings and has written and directed numerous animated films. He lives and works in Glasgow, Scotland. **P. 121**

POSY SIMMONDS, MBE, Prix de la Critique, was born in Berkshire in 1945. She studied at the Sorbonne and the Central School of Art and Design and is a cartoonist, illustrator and writer. Her work has featured in numerous publications notably The Guardian, The Spectator and Harpers Bazaar (USA). A writer/illustrator for TV, film and many childrens books she is best known for her characters Gemma Bovary and Tamara Drewe. **P. 33**

PAUL SLATER is an illustrator and artist whose work has been a staple of British publishing for over 30 years. He started drawing at a tender age under the influence of his father and older brother Tony, both of whom were habitual scribblers. He attended Burnley College in 1969 where he was taught to draw from observation by the brilliant Donald Matthews. He went on to study graphic design at Maidstone College of Art before gaining his MA in illustration at the Royal College of Art, London. **P. 84-85**

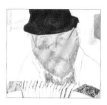

JENNIFER SMITH graduated from Cambridge School of Art in 2009. During her time on the Illustration BA course, she was awarded first prize in the inaugural Ronald Searle Award for Creativity. She is currently studying on 'The Drawing Year', an MA course at The Prince's Drawing School in Shoreditch, London. **P. 108**

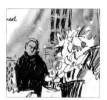

PAM SMY decided that drawing was a good idea at the age of six when her drawing was held up in front of the class and she got lots of praise for it. Studying illustration in the 1990's opened her eyes to drawing from life and she has kept sketchbooks ever since. Pam is now a Lecturer in Illustration at Cambridge School of Art where she is inspired by drawing on a daily basis. **P. 52**

RALPH STEADMAN was born in 1936. His illustrations have appeared in numerous publications, including Punch, Private Eye, The New York Times and Rolling Stone. He has collaborated with several major authors, most notably Hunter S. Thompson, including the iconic *Fear and Loathing in Las Vegas* and *Fear and Loathing on the Campaign Trail '72*. His editions of classic works such as *Alice in Wonderland* and *Animal Farm* have received many awards. **P. 71**

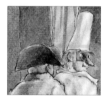

JOHN SUTCLIFFE worked for some years for The National Trust. For the past forty years he has been involved with decorative finishes and colours in historic and modern interiors. He has exhibited in Cambridge, London and Venice. A designer and cook, he is married, has children and grandchildren and is working on a book, *The Colours of Rome*. **P. 102**

GLYNN THOMAS was born in Cambridge and attended the Cambridge School of Art 1962-67. He taught printmaking at Ipswich School of Art 1967-79. He is a Fellow of the Royal Society of Painter Printmakers and has work in the Museum of London, the Ashmolean and Ipswich museums, and the Houses of Parliament Collection. **P. 95**

MONIKA UMBAR born Warsaw, Poland, studied Illustration and Animation at Cambridge School of Art. She has won numerous artistic competitions, such as: the Ronald Searle Award for Creativity, Cambridge Drawing Society and Cambridgeshire Film Consortium Animation Competition. Her art is mostly surreal and quirky, based around human existence, portraying life with tongue-in-cheek humour. Her artwork is sold in galleries in Cambridge, Esher and Tetbury. **P. 96-97**

JOHN VERNON LORD is a book illustrator, author and university professor. He has illustrated books on poetry, myths, fables, legends, epics, sagas, nonsense and children's books. His book *The Giant Jam Sandwich* has been in print for 39 years. His book *Drawing Upon Drawing* represents his thoughts about drawing and illustrating during the past 50 years and includes 396 images drawn by him. **P. 118-119**

STEWART WALTON was born in North London in 1952 and very soon after his mum put a pencil in his hand. That pencil is long gone but Stewart is still rarely seen without one. Drawing is his way of thinking, exploring and then explaining. **P. 40**

NEIL WARMSLEY was born in Upminster at the end of the District line, in 1962 . He came to Cambridge in 1988 where he still lives. His work as a gardener inspires his depictions of secluded corners of Cambridge. Neil shares the running of the weekly life drawing group P.O.S.E.R.S. (est. 1986) with John Holder. **P. 88**

HANNAH WEBB is a graduate of Brighton and has an MA in Children's Book illustration from Cambridge School of Art. She currently teaches drawing at Anglia Ruskin University and printmaking at the Curwen Print Study Centre. She also exhibits in several galleries around the UK and illustrates books for educational publishers. **P. 109**

ACKNOWLEDGEMENTS

Peter Mennim for image photography, management and
processing together with advice and encouragement.

Gaye Lockwood for planning, design and moral support.

Hannah Holder for computering, chasing and always being there.

Ted Hodgkinson for writing and editing.

Jacqui Batkin for the original database.

Eugene Gerber, Tim Oliver and Hannah Webb for help at the genesis.

Barbara Schwepcke and Harry Hall at Haus Publishing for believing in us.